MANGA &ANIME

Digital Illustration Guide

A HANDBOOK FOR BEGINNERS

Studio Hard Deluxe

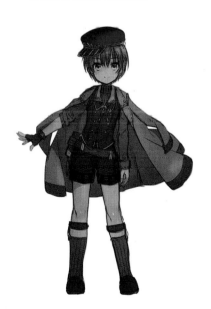

TUTTLE Publishing

Tokyo | Rutland, Vermont | Singapore

CONTENTS

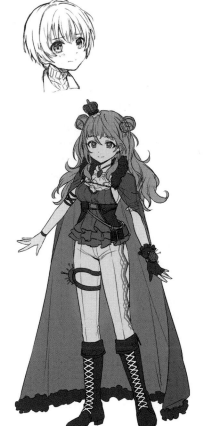

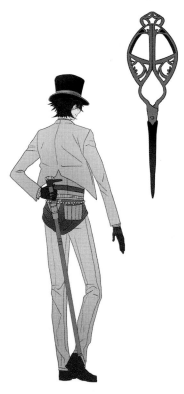

Why We Wrote This Book

In the world of manga, games, anime and graphic novels, a wide variety of characters appear as key players. Especially in character-based mobile games, their popularity is surging. In result, the demand for character illustrations continues to grow.

The phrase "character design" sounds formal, but there is no one way to approach it. It's simply the process of creating characters for a variety of visual platforms and often basing the appearance of the character on their personality and settings. However, even if you try to create an original character according to the story and settings you've chosen, you may find yourself stuck because the characteristics are not well organized and you can't ultimately create the character you desire.

This book is a guide summarizing how you can design characters and how to create illustrations for those who are new to the world of character creation, design and development. With that in mind, we'll be focusing on drawing for media that are in high demand such as manga, mobile games, graphic novels and other media. We'll be looking at the process of designing attractive,

appealing and bankable characters as well as the process of drawing a single illustration for those specific platforms. Throughout, we'll be illustrating key points and techniques shared by 12 illustrators who are active in the industry.

Chapter 1 introduces the process and flow of character creation and the basics of character design.

Chapter 2 and **Chapter 3** introduce how to design characters according to the requirements prescribed by various media and platforms. **Chapter 2** posts four character boards for mobile games, and **Chapter 3** introduces six character boards for print media such as covers and posters.

Chapter 4 has two character boards of fan art and character design, using a popular shoot-'em-up game, "Touhou Project," as the model. Check it out!

We hope that you can design your very own characters and that they find life in your various and evolving artistic and professional pursuits.

— STUDIO HARD DELUXE

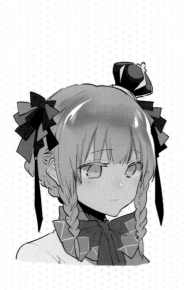

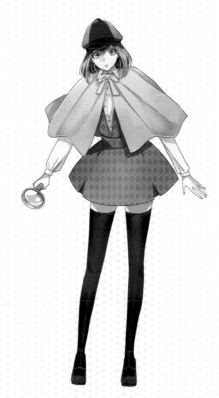

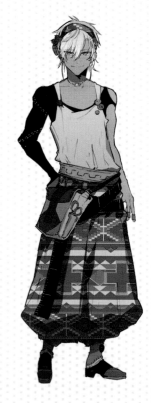

How to Use This Book

Understanding how to create character designs and illustrations

This book is a guide that'll help you with character design and how to draw illustrations for a variety of visual and entertainment platforms. A total of 12 illustrators, who are currently working in the field, have created character illustrations with various styles and modes for you to reference.

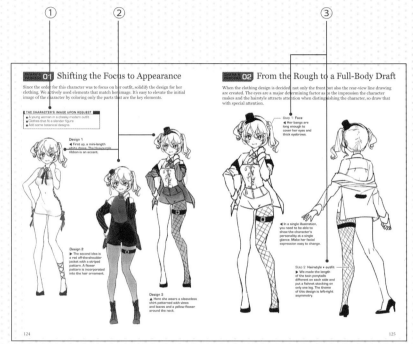

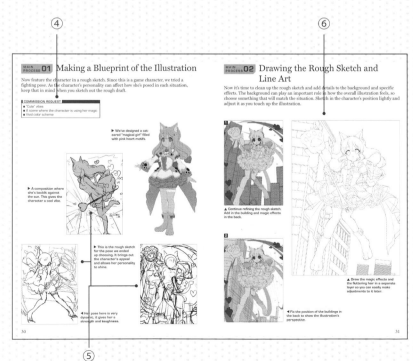

CHARA'S PROCESS 01

This icon indicates we're exploring character design. On these pages, we'll explain how to create, mold and shape a character.

① Developing a character on commission. We create the character based on this content.

② Rough character sketch. Here we'll be illustrating a few rough designs for the character.

③ Explanation of the procedure for designing a character. Each example explains important points in character design such as facial features, hairstyle and clothes.

MAIN PROCESS 01

This icon indicates that we'll be examining the procedure and process of creating illustrations and how to complete the illustration.

④ Conditions of the commission. We'll make a rough sketch of the illustration based on this information.

⑤ Rough image of the completed illustration. If multiple rough sketches are made, we'll be showing all of them.

⑥ Production of the illustration. We record and explain the elements that affect the impressions created as part of the process.

CHAPTER 1
Basics of Character Design

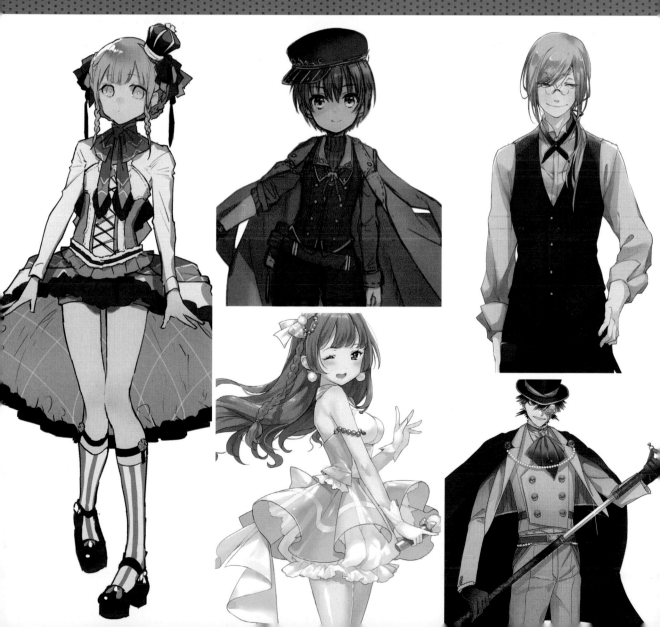

What Is Character Design?

Graphic novels, manga, games: we're drawn to the characters that drive the stories they tell. In order to create an attractive character, first, we must think about the details: the character's outfit, personality, special abilities and qualities.

What makes a character?

There are many elements that make up a character such as individuality, personality, special skills and occupation. Many characters are designed in a way that you can imagine their personality just by looking at their appearance.

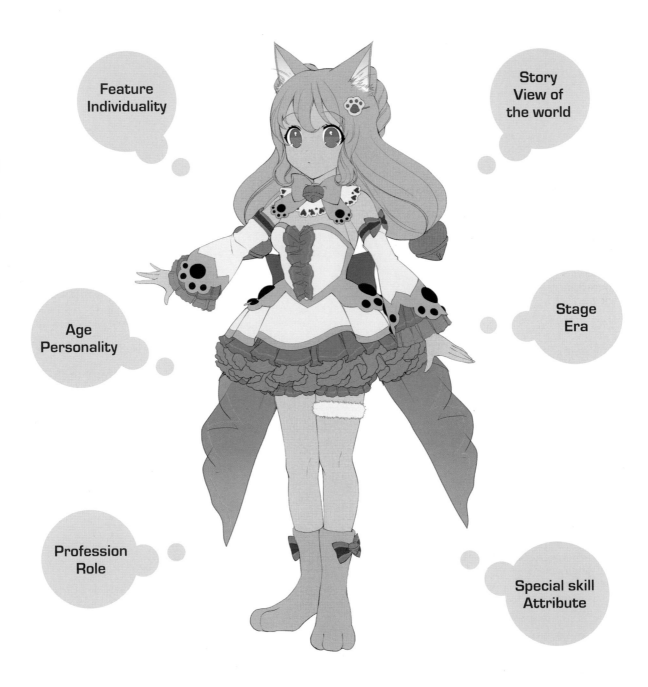

Feature
Individuality

Story
View of
the world

Age
Personality

Stage
Era

Profession
Role

Special skill
Attribute

Parts and elements that reveal personality

By nature, we comprehensively judge a character's personality by looking at his, her or their face, body, clothes and accessories. Good character design is achieved by knowing what each part or element represents.

Face / Hair / Expression

The face is an important part that can be referred as the "life" of the character. The combination of eye color, hair color, hairstyle and facial expression can exhibit many of the character's factors such as age, personality, nationality, status and even strength.

Body Type / Pose / Mannerism

The body shape can help express the character's age and strength. For example, a young child is small, slender while an aggressive enemy is muscular. The poses and gestures will bring out the character's individuality and personality.

Clothing / Accessories

The clothes and costumes reflect the age, setting, profession and status of the world the character inhabits. In addition, you can make it easier to understand roles, special skills and hobbies depending on the character's props or accessories such as a witch's wand or a fashionista's purse.

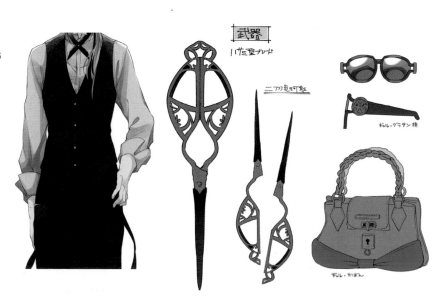

Characters in Different Medias

Characters are needed as the driving force behind manga, anime, games and graphic novels. First, let's take a look at character creation in the respective formats.

Mobile Games

In many mobile games, such as social games, the appeal of the illustration is directly linked to the success of the game itself. Therefore, new characters and illustrations are updated frequently. Since the illustrations are the main focus, designs tend to focus on easily recognizable persona.

Character Merchandise

Merch! It comes in many forms, and all require a compelling persona in a powerful pose. Here the emphasis is on the character's charm and commercial appeal while always keeping the target audience in mind.

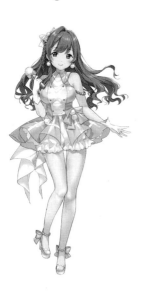 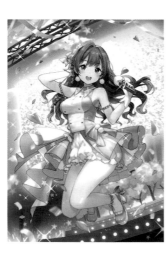 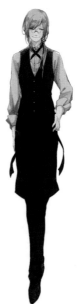

Manga and Graphic Novels

With manga and graphic novels, the characters are essential to the story. Although the characters are created according to their role in the story, it's also important that they're distinctively and definitive in order to capture readers' attention.

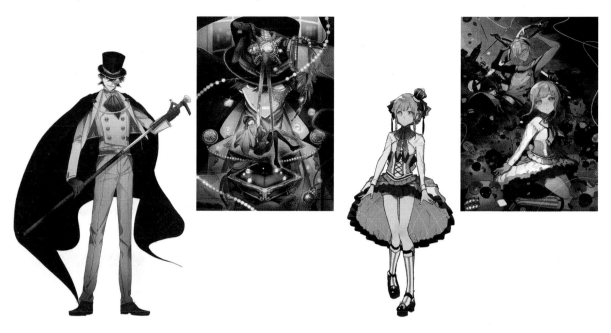

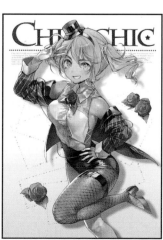

Magazines & Print Media

Ads, posters, magazine covers: characters are prominently featured in these outlets too. The illustration should highlight the character's appeal and charm and should draw in readers at first glance.

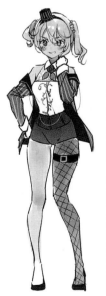

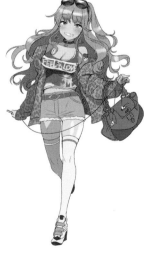

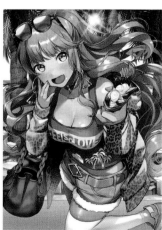

Basics of Creating a Character

Here, we'll be showing the flow of character creation, from head to toe, so you can get a detailed breakdown of each step.

Character design flow

There are two basic models or directions: create your own original character or develop one based on the drafts, settings and illustrations made by others. In each case, it starts with thinking about what you want to draw and ultimately accomplish and then making a rough sketch from there.

Original Character

Have the freedom to come up with any idea or conception without having to consider any other opinions or professional constraints

Pre-determined drafts and specs

You'll have to work with drafts and specifications that someone else has provided for you. There are a wide variety of cases, from production commissions for games and books to mixed media illustrations from existing works to fan art.

Imagine the elements you want to include

Think about the type of things you want to include and the intended audience for the character. The point is to emphasize and elevate the details, whether you're drawing for yourself or for others.

Think about the characteristic elements

In the case of commissions, consider elements that are important to request. In the case of fan art, consider character's the key characteristics and defining qualities.

Rough Draft

This is the most important step in creating your character, in getting it out of your head and onto the screen. By actually sketching out a rough draft, you can clearly see the missing elements and find points that need to be improved. In the case of working on commission, you can even show the client the rough sketch to see if it fits with their conception and specifications.

Revise & Refine

At this step, refine the character's appearance based on the rough sketch as well as feedback from the client. From the overall balance to the details, repeatedly check whether each element is expressing the character as intended and, if not, make the necessary adjustments.

Final Touches

Now we're ready to generate and finalize the completed character. In the case of a commission for a single illustration, such as for a mobile game, the illustration itself becomes the character design.

Various design approaches and steps

Here, we'll introduce some practices, processes and procedures followed by the illustrators of this book.

Make a rough design

Roughly design the elements that you came up, and then use them as reference to create a more detailed design.

1. Think about the overall image of the character you want to draw.
2. Draw a body with a strong profile and a pose that suits your image.
3. Add on to that idea by designing the character's hairstyle, clothes and accessories.
4. In step 2 we laid down the blueprint; in step 3 we add more elements, using these two stages to create a final sketch for the character design.
5. Consider the silhouette and make a detailed design.
6. Add small items while looking at the balance of the silhouette. Finalize the design until you're satisfied with it.

Start with the personality

Devise the character's personality, then move on to the appearance and characteristics.

1. Conceive of the character's personality.
2. Imagine different facial expressions and hairstyles that match the personality.
3. Think of various poses and clothes to match the facial expression and hairstyle.

Start with the world view

By imagining the environment surrounding the character, you can associate it with the role the character fulfills. From there, it'll help guide you with coming up with the character's image, costumes and accessories.

1. Think about the character's world view.
2. Think about what kind of profession or position the character is in and visually reference it.
3. Consider the settings and the character's personality and solidify the design.
4. Think about the clothes and belongings that the character is likely to wear or carry.

Imagine the character's personality after designing the appearance

Develop a character's personality based on the impression you get from the appearance. If you think about the personality first, you can lose the surprising way a character comes to life.

1. Roughly sketch a character's appearance until you think "that looks good!"
2. Imagine the character's personality from the sketch you drew.
3. Build upon the character's design as you imagine the personality.

Start with an overall silhouette

First think about the character's overall silhouette, such as the height and body size. From there, you can start thinking about other parts of the character.

1. Start the character's design by determining the silhouette (outline).
2. Determine the face shape.
3. Determine the hairstyle.
4. Finally, devise a detailed clothing design.

Gather information from other characters

Collecting information from similar characters that already exist can help you solidify the image of the character that you want to create.

1. Try searching for 10 or more characters with different and similar features.
2. Determine the character's personality by referring to the character you're most drawn to.
3. Determine the pose or silhouette that best suits your character's personality.
4. Determine the various facial expressions.
5. Determine the hairstyle and clothes.

The eyes are key

The eyes are important as they strong shape the first impression a character makes. Start the design from the eyes, then spread to other parts of such as their hair and clothing.

1. Determine the shape of the eyes.
2. Determine the hairstyle.
3. Determine the body shape.
4. Determine the costume.

Other tips

Emphasize the important points
Find the key, defining elements and be find the design that emphasizes them best.

Decide one or two themes for the overall clothing and decoration
If you focus on the theme, the design will be more cohesive.

Imagine a motif from the theme and incorporate it into your costume
For example, if a "cute" persona is needed, you can write down your thoughts such as hearts, pinks, ribbons and frills and combine them with your character.

How to Develop a Character's Design

In order to make your character as appealing as possible, it's important to add details. Try jotting down as many ideas as you can and use them to add strong, defining characteristics and elements to your character.

Add another element to the core personality

First, think about the character's core personality. Use that personality as a defining element to expand into more detailed aspects. It's also a good idea to think of opposite qualities such as their weaknesses. If there's a rival or a love interest, imagine their relationship and how they treat each other. You can add or remove certain personality elements as progress along the designing process.

Serious boy

Strict with himself and other people

Gets angry when his sister is being spoiled or fawned upon. Always defending his sister from his friends.

Analyze and incorporate related elements

If the character has a fixed role, such as having a specific profession, you can easily research it. Then write down what you find and things that left an impression in bullet points so that you can possibly incorporate those elements into the character design. Think about what kind of conversations the characters will have with each other, this way you can expand the setting to make the character's personality even richer.

Occupation is a blacksmith

The material is mainly metal Has a hammer Wears goggles for protection

Muscular physique with a big hammer.

Imagining a private or inner life

It's easier to come up with a character's personality and setting when you think about how she or he would behave in daily life: are they clean or messy, quiet or loud? Write down simple details that accurately reflect the character's world or enliven the scene, and then build on the character's appearance based on these elements.

Is softspoken Room is clean and neat

Wears glasses The clothes and hairstyle are tidy

A boy with poor eyesight but a sense of cleanliness

Try to put in your personal favorite elements

Unless specified otherwise, start with your personal favorite elements for both the character's personality and appearance. From there, you can add various settings one after another, including elements that will appeal to the character's target audience.

I like romance manga I like hearts as a design motif

The target audience is those who like traditionally "cute" characters

Give the character a costume covered in a heart motif

Decide on a theme

Decide on a theme that's important to you, and expand the character's image according to that theme. You can still use this method with commissions with fixed parameters. While being careful not to deviate from the specs, devise a character that has a personal impact.

The theme is "movement"

Exaggerate the hair length so you can add to the "floating" sensation Incorporate fluttering garments

Choose a pose that utilizes fluttering hair and clothing

Try to think of settings that are not reflected in the illustration

If you're working on a character that transforms, try to imagine their appearance before the transformation. Although that appearance will not be reflected in the final illustration, it helps build character. New ideas can stem from drawing their ordinary form, for example, making the hairstyle more eccentric than before the transformation.

Will be drawing a magical girl

The hairstyle before transformation is a semi-long twin tail

After transformation, make it a super long twin tail

Other tips

Design to match the specified color
For works such as mobile games, there are many cases where the character's hair and eye color are specified in advance for the commission. This means the color scheme is important to the design.

Divide the style by world view
For works of genres with a specific aesthetic, such as fantasy, be careful not to add elements that don't match. On the other hand, if you narrow down and define the character's personality to the point that he or she is readily recognizable, it'll add a sense of familiarity and make the character more relatable.

Thinking about the appearance

First imagine the character's overall appearance and color scheme, then think about what kind of attribute fits the character best. From there, you can think about "what kind of person would enjoy wearing this type of outfit?" and sketch out facial expressions and small items to match that personality.

Traditonally feminine attire Mainly pink

Bright Well-groomed

Make a proud expression Have a leather bag or smartphone

Expand your imagination while drawing

It's a good idea to think about what elements to add on as you're drawing the character. Even when drawing for commissions, it's effective to devise the facial expression you want to draw even if the setting hasn't been fully planned out yet. You can start building on the character's personality from there and add elements that are specified in the commission, such as their clothing and setting.

A

Will be drawing a boy

Try adding plain clothes

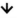

Since he wears this kind of clothing, he must have a serious-type personality.

B

Draw a rough picture

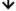

Find an appealing pose

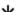

A young woman who looks like this seems to have a rough side

Making a Character Chart

A schematic outline of the character you want to create serves as a blueprint to guide you as you add layers of detail and coloration that bring your persona to life.

Rough Sketch

Draw a full-body view of the character based on the elements and settings that you have considered. Once you draw out the entire character, this will help identify parts may not work in the design as well as you imagined. Analyze the sketch and think about what is different from your original conception, then make adjustments until you get your character closer to your ideal look.

Picking a color scheme for the character

The color scheme greatly affects the impression of the character. You can roughly assemble the palette you want to use. By doing this, it'll help you understand each aspect of the character's persona as well as help prevent mistakes, such as poor color balance in your illustrations.

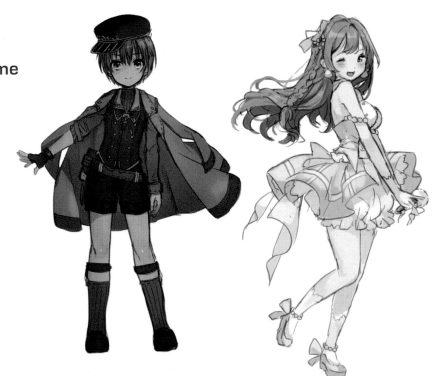

Make a facial expression gallery

Once you have a solid design for your character, let's try drawing the character with different facial expressions that suit their personality. Not only basic expressions such as happy, angry, crying or surprised, but also draw unique facial expressions that'll add depth to the character.

Draw a pose

When you draw characters in casual poses, you come to understand them better. Sometimes poses are the best way to bring out the character's personality. If your work features multiple characters, such as in manga or graphic novels, it's a good idea to imagine the relationships between each of your characters.

Draw out their belongings

Imagine the characters' professions and hobbies, then draw items such as their belongings and accessories. When you include their belongings, you'll be able to more clearly show the character's identity, tastes and defining habits.

Character Illustration Production Steps

Start with a rough sketch, drafting the basic shape and form of your character. Once you've laid down the groundwork, adding color, shading and highlights rounds out the process.

Create the rough sketch

Rough out the composition that will act as the illustration's blueprint. The point is to show how each element fits into the frame, as in the example shown here, the emphasis of the content differs for each type of media.

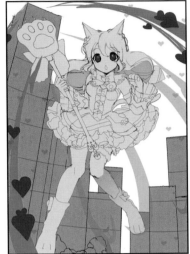

Mobile games

Since this is the first time the character will be shown, draw a full body composition showing the legs too. There are many different compositional schemes for full-body illustration. Regardless of the angle or proximity you choose, try to at least include the thighs. For details, go to page 20.

Manga and graphic novels

The main goal is to convey the atmosphere, world view, and theme of the story. Devise a composition that emphasizes the size of the character and gestures to the narrative that unfolds between the covers. For more details, go to page 70.

Draft and Line Art

Make a clean copy as you move along the process: rough sketch → draft → line art. At the drafting stage, modify the drawing to keep the overall balance. The line art process is important not only for a clean finish but also for the efficiency of the color scheme. So keep that in mind when working on the drafting process.

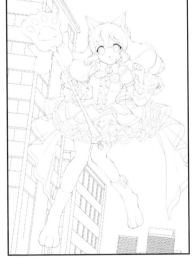

Precautions when creating line drawings

- Keep good balance for the draft lines.
- Since we'll be lining the art later, don't be too conscious when sketching out the draft.
- Don't draw wrinkles on clothes too finely. Too many details will make the coloring process more difficult.
- To make the coloring process easier, don't leave gaps between lines.

Adding the base color

Using the bucket tool, bleeds or add the base color to the entire illustration. If any color bleeds or spills into other spaces, undo and fill in the gaps, reapplying the color with the bucket tool. Adjust the color balance while looking at the illustration as a whole. After finishing the base color, apply some gradients to the parts you want to change, adding shading as you do.

An example of the color scheme

- Make a strong impression using up to 3 main colors
- Pick the accent color to strongly contrast with the main color
- Choose colors from the same family
- The color scheme for the clothes should comprise 3–4 colors.

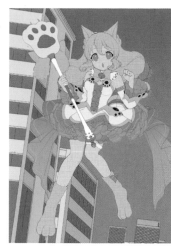

Apply shadows and highlights to the outline

Paint in darker colors to capture the shadows in the illustration. For illustrations with backgrounds, add a color that will indicate the background's general shade. After painting in shadows, add highlights to areas that are directly reflecting light and add sparkle to the eyes. Last, contour the skin and adjust the color balance for the entire illustration.

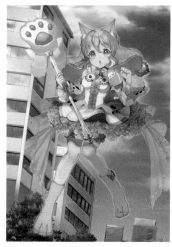

Process and finish the illustration

In order to improve the overall illustration, add in effects and correct the color. Processing is an important stage that affects the overall quality, but be prudent and selective: it may alter or mitigate the strengths and unique qualities of the illustration, so be careful not to go overboard and only make necessary adjustments.

Color scheme example

- Add glow effect
- Add blur
- Paste a texture to give an analog feel
- Adjust brightness and contrast
- Adjust the color

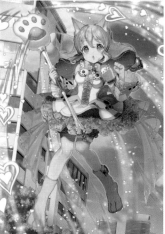

Tips When Creating Illustrations

RGB and CMYK

RGB is the usage of the three primary colors + light (mixing of the three primary colors + adjusting the brightness as we mix the colors), while CMYK uses a subtractive color model (reducing the color mixture). CMYK generally works better with printed/paper media. Commercial printers often use CMYK because it creates vivid colors that RGB mode may not be able to reproduce. If you already know that the illustration you'll be creating will be used in printed media, you can create an illustration in CMYK mode in advance for better results.

Also, as a precaution when printing with CMYK, if there's a place where the total amount of ink exceeds 300%, there may be printing issues because there's too much paint at the time of printing and it becomes difficult to dry, which may cause bleed-throughs. There are many ways to deal with it, so you need to find a method that suits your illustration.

Inkjet printers, which are popular among home users, employ special ink to print in RGB hues. Even if it looks good on your home inkjet printer, the colors may look different when printed in a commercial magazine, so be careful when setting the color modes.

Know which format will be used to print your illustration. There are subtle but significant differences between the two processes.

Resolution

Compared to general smartphones and computer monitors that look good enough even at a resolution of 72dpi for the Web, printing on paper requires a high resolution of 350dpi in color. Data with the same vertical and horizontal width but low resolution end up printing in poor quality. So you need to be careful about the size and resolution from the illustration's initial set-up. However, even if the resolution of the data is 72dpi, if the vertical and horizontal width of the data is about 5 times or more larger than the actual vertical and horizontal width, a sufficient vertical and horizontal width can be secured even if the image is reduced to a resolution of 350dpi. In this case, there's nothing to worry about.

Precautions for software used
Precautions when creating PSD files other than Photoshop

The major PSD file as the delivery data format for illustrations is the image file format used in Adobe Photoshop of Adobe Systems, and even recent illustration software such as CLIP STUDIO PAINT and SAI Paint 2 supports PSD exports as a standard. Since the specifications of corrections and effects using layers differ depending on the software, the effects may not show up correctly when loaded with Adobe Photoshop or other Adobe Systems software. If you deliver your PSD file to someone else, you need to be careful because there's the possibility that the illustration will be used in a way you didn't originally intend.

As a work-around, you can pass the data that integrates the layers as well as exporting the completed sample as an image file such as a png file, and attach it. If the client has requested the delivery of data in separate layers, it will be easier to prevent problems if you also send the above integrated data and sample images together.

Designing Characters Used in Mobile Games

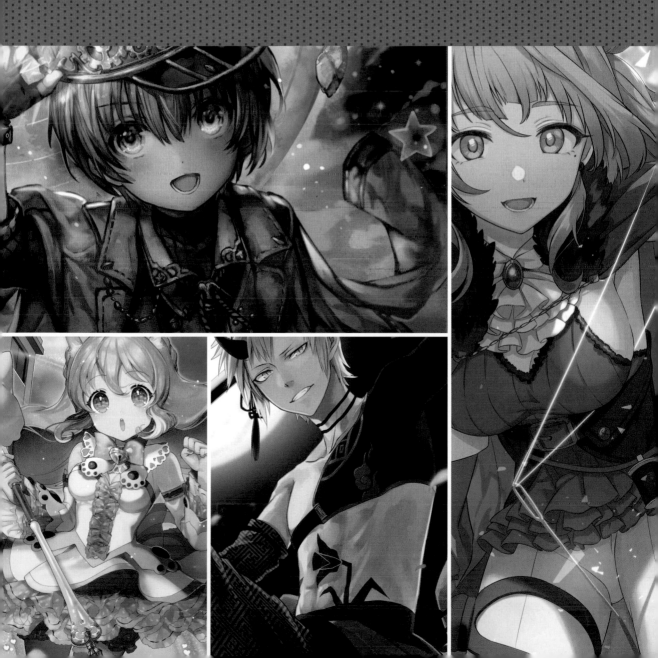

Illustrations Used for Mobile Games

When creating games for mobile devices, the development process is hardly any different: proceed from a rough sketch, filling the screen with dynamic details. Just remember to consider your character's story arc before you begin.

Prepping for the Illustration

TIPS

- **Understand the world view of the character**
- **Capture the most important appearance features**
- **Gather materials**

Generally, mobile game illustrations are drawn at the request of a gaming company. Study the source material and get a good grasp of the game world such as the setting and era and understand what elements the client want to highlight from the commission request.

Depending on the world view of the game, there may be motifs to consider, such as historical armor or traditional costumes. You can improve your work efficiency by studying the materials in advance, doing research and consulting reference material, so that once you start on the project, you already have an idea of how to proceed.

Thinking about Composition & Poses

TIPS

- **Choose a composition and pose that include the character's entire body**
- **Character should focus on the viewer**
- **Add depth to the screen**
- **Draw all the elements to be included when you're completing the rough stage**

Since the character illustration itself is often the key graphic or icon, it's important to create a full-body composition where you can still imagine the pose even if part of the image gets cropped. If the character is looking straight at the player, this is the most effective pose. At the rough stage, consult with the client about the details to include in the background.

▲To avoid giving the illustration a sense of static flatness, we made the hand on the right side protrude toward the front. This ads depth to the illustration. By using a slightly higher angle, this is also effective in creating a three-dimensional feel.

▲The character's line of sight should be directed at the player even if a high- or low-angle perspective is being used. In order to ensure the players can tell what exactly the character looks like, make sure the body is in frame up to right below the knees.

Character Design

- Include motifs that shows the character's occupation/role via their items and costume
- Keep in mind the character's unique traits
- Express the character's personality and atmosphere with facial expressions and gestures

In order to design a character you can identify at a glance, use easy-to-understand motifs, costumes, weapons and accessories. Similarly, you can use facial expressions, gestures, and poses to evoke the character's personality and atmosphere.

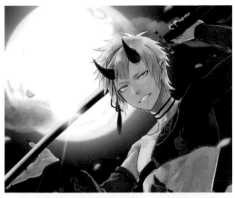

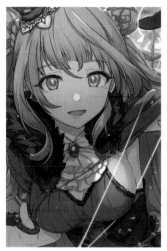

▲ A definitive presence is key: introduce details to costumes that reveal subtle defining characteristics. For some characters in mobile games, an evolving look or character arc needs to be accommodated.

▲ To bring out a "demonic" vibe, we gave him a horn growing from the forehead and a Japanese-style sword. Then, to bring out his adventurer vibe, we gave him a rolled-up map sticking out of his bag, and shiny gems all around the illustration. These are some of the ways you can suggest the character's unique traits.

Think about Character Evolution

- Bring out the unique elements
- Fill the screen
- Increase special effects and decoration
- Show character growth

For mobile games where there are characters that can evolve, the goal is to make the players want to embrace those characters and evolve with them. Glorify the illustration, show growth, think about how the character's narration has advanced.

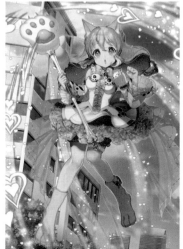 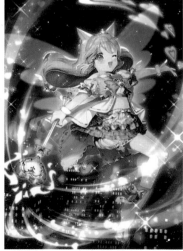

▲ An innocent magical girl (left) evolves into a confident and respectable wizard (right). Her outfit, staff and the magic effects change, making the illustration seem both elevated and refined.

Before-and-After Transformations
Magical Girl Illustration

As a mobile game character, we've designed a young woman imbued with magical abilities. Since this character changes form, when designing her, think of her transformation into an enchanted and powerful presence.

Illustration by **Moshiki**

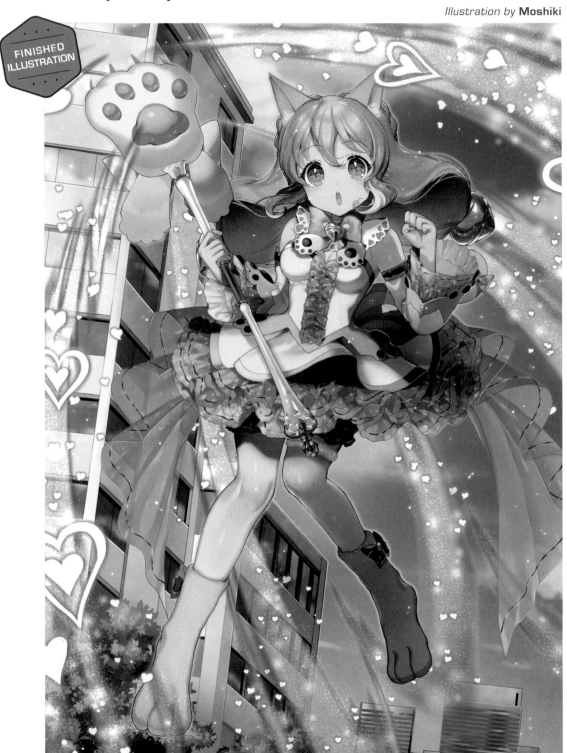

FINISHED ILLUSTRATION

Magical Girl Transformation Illustration

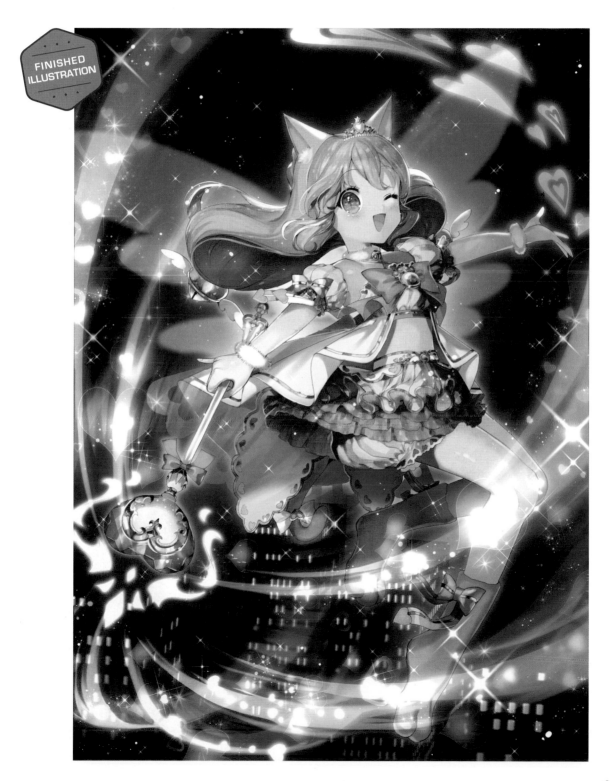

FINISHED
ILLUSTRATION

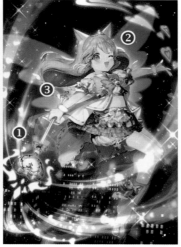

① Make sure the effects don't block the character

② Show her pre-transformation elements

③ Make the background drastically contrast to create a strong impression.

CHARACTER
Magical Cat Girl

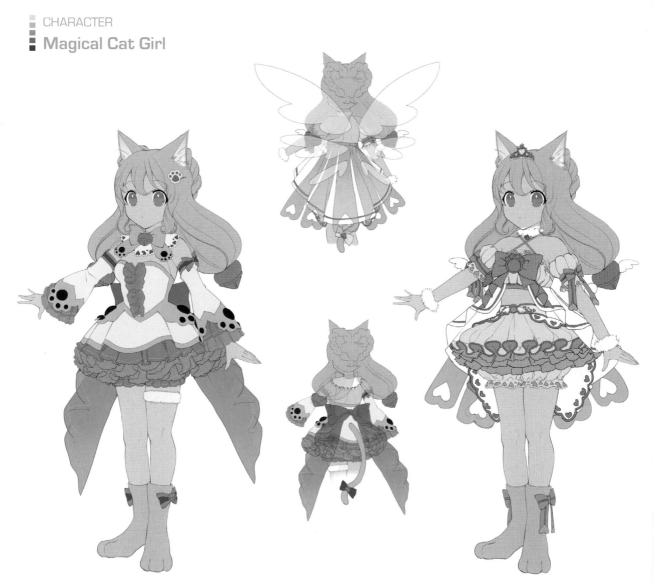

Creating a Design Board

For this illustration, we're conjuring a traditional "magical girl." First, create a detailed schematic. Using the character "image" memo to build on, add in elements to flesh out the character design.

ITEMS FIT THE CHARACTER'S IMAGE

- A magical girl with ribbons, frills and hearts
- Incorporate animal elements into the design
- Include a magical gadget

▼ This design features a ribbon on the chest and large frills on the skirt. Cat elements are scattered everywhere, along the arms and in the hair accessories.

Design 1

Design 3

Design 2

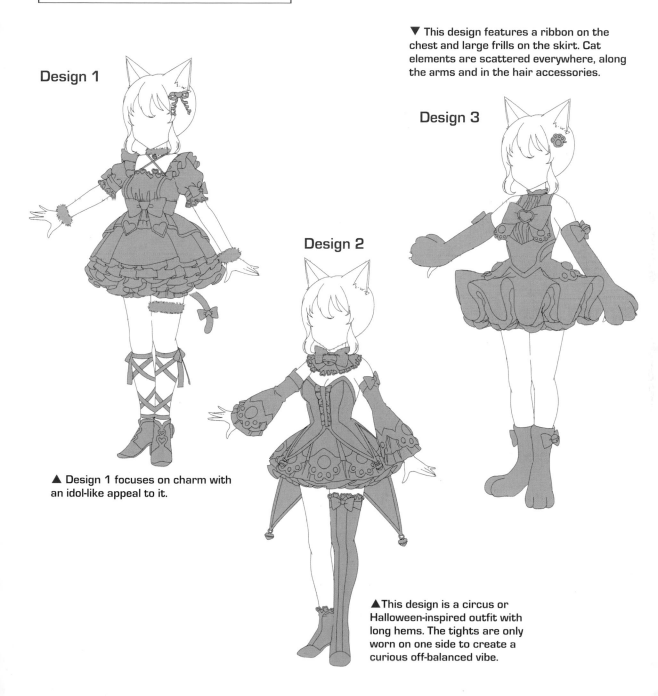

▲ Design 1 focuses on charm with an idol-like appeal to it.

▲This design is a circus or Halloween-inspired outfit with long hems. The tights are only worn on one side to create a curious off-balanced vibe.

CHARA'S PROCESS 02 Deciding on the Hairstyle and Outfit

Using the designs from the previous step, it's time to combine elements into the final outfit. For this example, we went for the cat-themed outfit. Now, the hairstyle will finish off the design. If you can't decide on a hairstyle, you can change it up based on the details added to the outfit.

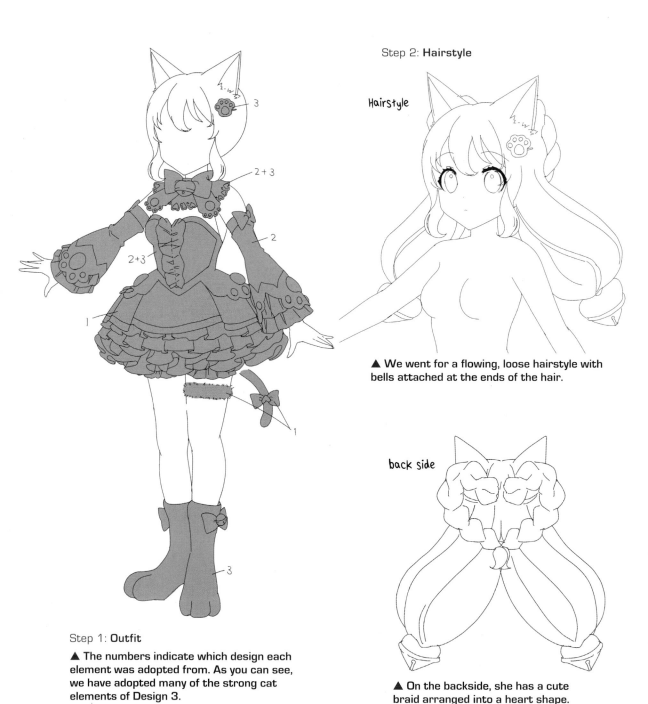

Step 2: Hairstyle

Hairstyle

▲ We went for a flowing, loose hairstyle with bells attached at the ends of the hair.

back side

▲ On the backside, she has a cute braid arranged into a heart shape.

Step 1: Outfit

▲ The numbers indicate which design each element was adopted from. As you can see, we have adopted many of the strong cat elements of Design 3.

Accessories to Match the Character

Now that we're done designing the character's outfit, it's time to design her magical accessory. For this illustration, let's give her a magical wand! Here are two versions, a cat paw version and a crystal heart version.

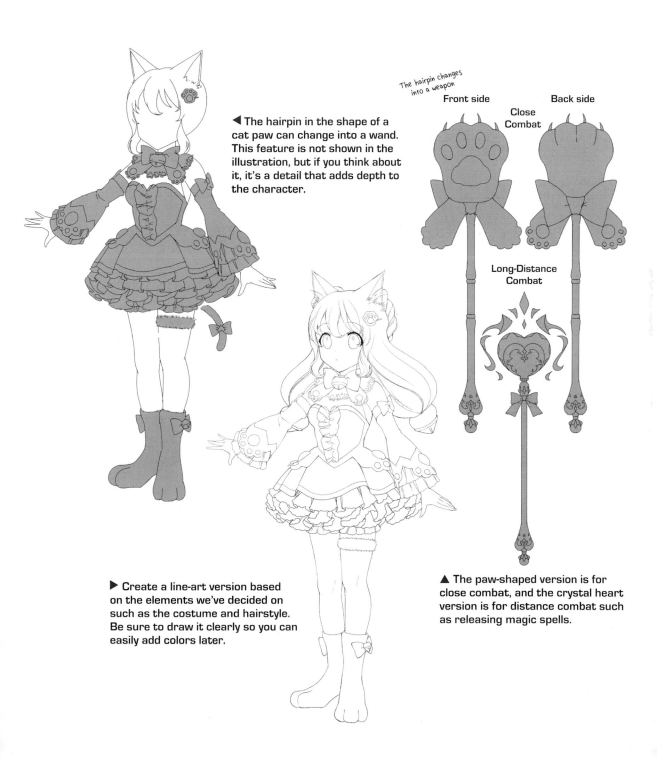

◄ The hairpin in the shape of a cat paw can change into a wand. This feature is not shown in the illustration, but if you think about it, it's a detail that adds depth to the character.

The hairpin changes into a weapon

Front side Back side

Close Combat

Long-Distance Combat

▶ Create a line-art version based on the elements we've decided on such as the costume and hairstyle. Be sure to draw it clearly so you can easily add colors later.

▲ The paw-shaped version is for close combat, and the crystal heart version is for distance combat such as releasing magic spells.

Designing the Character's Color Scheme

Try out different color combinations on the line art you've created. When choosing a color palette, think of the character's personality, magical attributes and unique abilities to pick a theme that matches the character. If you use a fixed amount of colors, you'll achieve a more cohesive look.

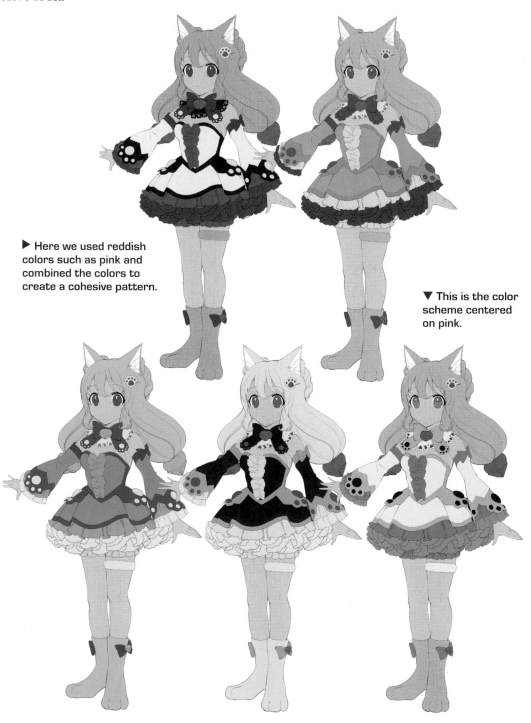

▶ Here we used reddish colors such as pink and combined the colors to create a cohesive pattern.

▼ This is the color scheme centered on pink.

Finishing the Character's Final Silhouette

Based on the colors chosen for the character, add in details such as the lace patterns. With a long ribbon on the back side, this is a key element to the character's silhouette. You can also add dynamic movements to show the character in motion.

▼ Pink is used as the base color, and gold and brown are used as secondary colors. We decided to use a light blonde for her hair color.

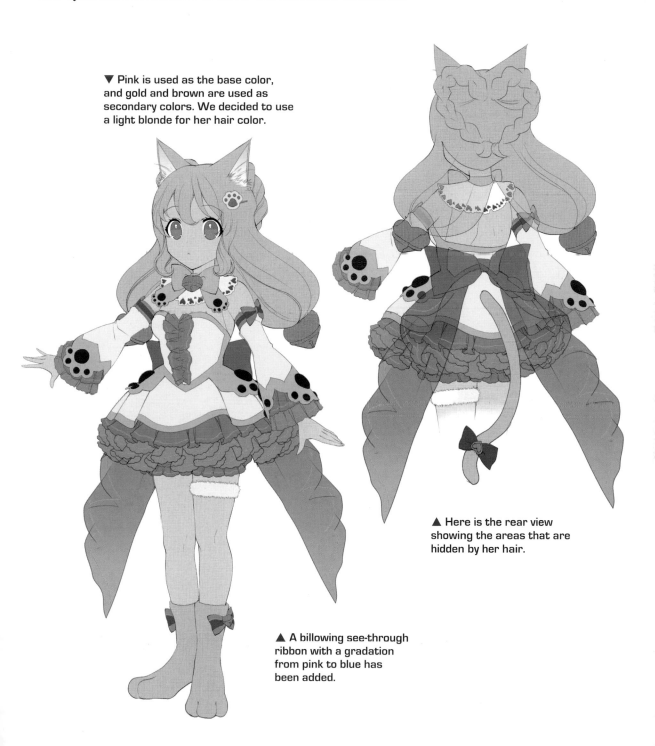

▲ Here is the rear view showing the areas that are hidden by her hair.

▲ A billowing see-through ribbon with a gradation from pink to blue has been added.

MAIN PROCESS **01** Making a Blueprint of the Illustration

Now feature the character in a rough sketch. Since this is a game character, we tried a fighting pose. As the character's personality can affect how she's posed in each situation, keep that in mind when you sketch out the rough draft.

COMMISSION REQUEST

- "Cute" vibes
- A scene where the character is using her magic
- Vivid color scheme

▶ We've designed a cat-eared "magical girl" filled with pink heart motifs.

◀ A composition where she's backlit against the sun. This gives the character a cool vibe.

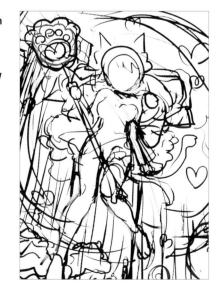

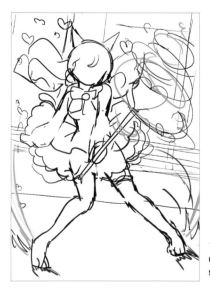

▶ This is the rough sketch for the pose we ended up choosing. It brings out the character's appeal and allows her personality to shine.

◀ Her pose here is very dynamic, it gives her a strength and toughness.

MAIN PROCESS 02 Drawing the Rough Sketch and Line Art

Now it's time to clean up the rough sketch and add details to the background and specific effects. The background can play an important role in how the overall illustration feels, so choose something that will match the situation. Sketch in the character's position lightly and adjust it as you touch up the illustration.

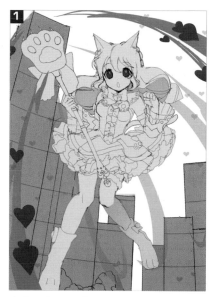

1

▲ Continue refining the rough sketch. Add in the building and magic effects in the back.

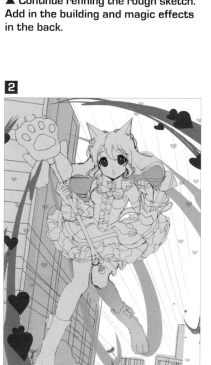

2

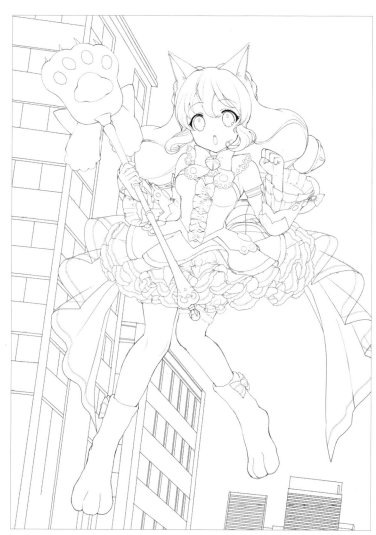

▲ Draw the magic effects and the fluttering hair in a separate layer so you can easily make adjustments to it later.

◀ Fix the position of the buildings in the back to show the illustration's perspective.

MAIN PROCESS 03 Adding Dimension to the Character

For the next stage, add color to the line art. Using thick lines allows you to make adjustments later on. By adding shadows and highlights to the base colors, you can really add dimension and dynamism to the illustration.

▲ Adding various colors as the base color.

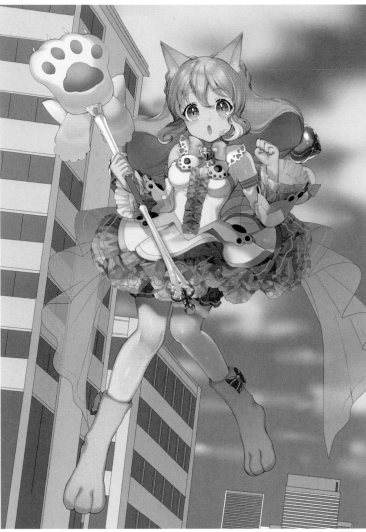

▲ Continue to add shine to the character.

▲ The impression looks quite different just by adding shadows.

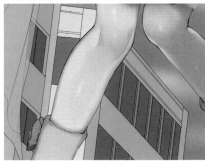

▶ While coloring the skin smoothly, also add shadows and shine to the knee area to create a three-dimensional effect.

MAIN PROCESS 04 Adjusting the Character's Colors with the Background

Now add details to the items such as her costume and staff as well as the buildings in the background. Ensuring that the character stands out from the background is an important factor, so keep the balance in mind and adjust the colors as you go.

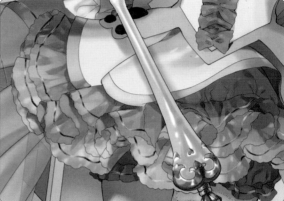

▲ Enhance the golden accents on the skirt and staff. Think carefully how the light reflects.

▲ Add dimension to the staff and the see-through ribbon in the back.

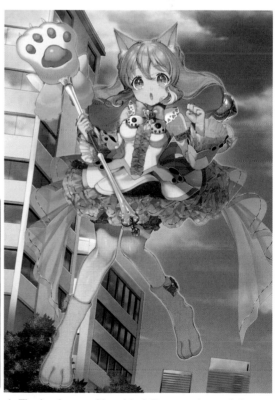

▶ Even on the walls of the same building, the colors will vary greatly depending on how the light hits them.

▲ The background is added. Be conscious of the light source and try to elicit a sense of sharpness.

Adding Special Effects

Keep in mind that the magical power is coming from the paw portion of the staff when adding the effects. Think also about the direction the magic effects are coming from and adjust the color to match the character.

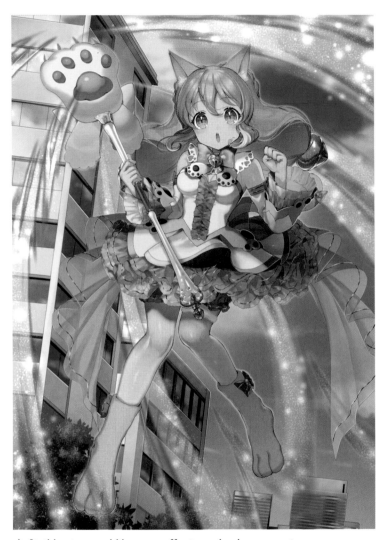

▲ The claws of the wand are shining. Also, the swirling effect is studded with her heart motif.

▲ At this stage, add in more effects and enhancements.

▲ The color of the eyes was a little too similar to the color of her skin, so we added pink.

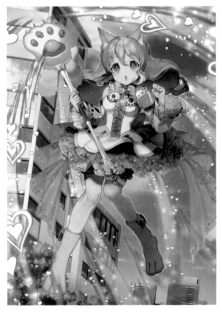

▲ The shadows are darker to enhance the overall contrast.

Complete Transformation Design

For games that have a level-up aspect to them, the character can gain experience and "evolve." Along the way, the character's appearance changes as well. In this case, we're focusing on the character after her transformation.

COMMISSION REQUEST
- A clear difference between the before and after transformation
- More vibrant design
- Changes to the crystal heart staff

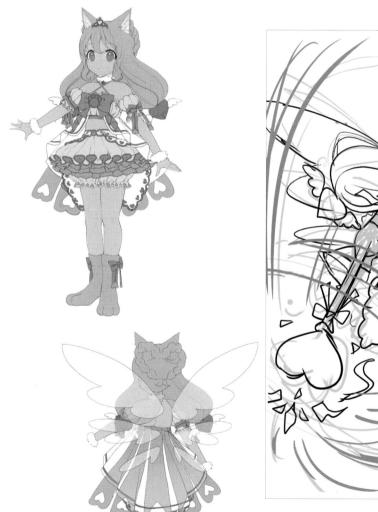

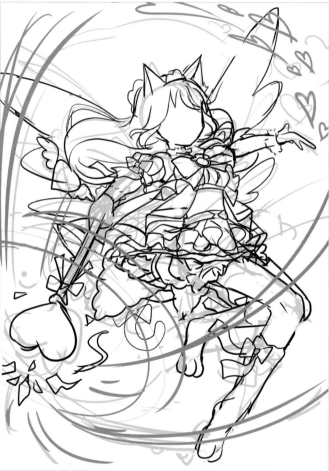

▲ The extent of the character's growth is also expressed in her complex and active pose.

▲ She now has wings and her outfit is golden. While retaining the character's appeal, we gave her a more refined feel as well.

Create the Line Art and Polish the Character Design

Start the illustration by creating the line art for the character. Include base color, highlights and shading to add dimension to the illustration. For areas where the colors are dark, add some shine to give it an airy feel.

▶ We're using a lot of yellow because gold is one of the requested base colors.

▼ This is the line art of the illustration. Her expression is now much more bright and confident in comparison to her pre-transformation form.

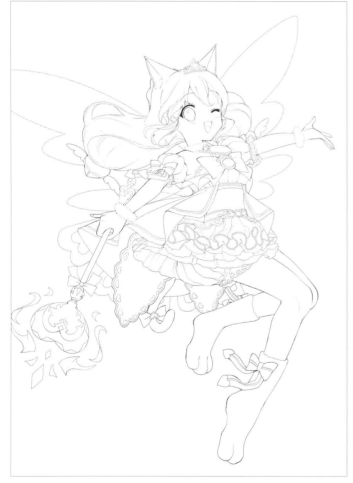

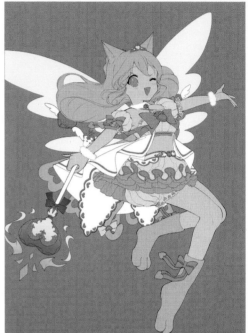

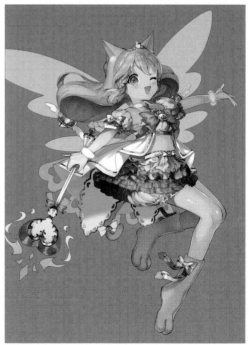

▶ Brightening the highlights adds luster and shine.

Adding an Even More Vibrant Magical Effect

After you're done adding color to the character, we'll now add the magical effects to the illustration. Make sure that the effects don't block the character. Finish the illustration by making the character pop, grabbing the viewer's attention.

▶ Magic is unleashed from the center of the crystal heart staff. Besides the light of the magic itself, the crystal part of the staff is also shining.

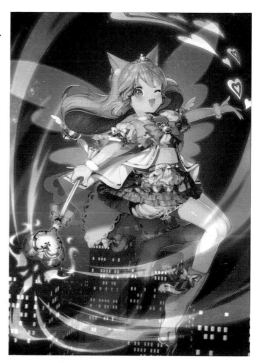

▼ In this illustration, it's nighttime, another differentiating detail from her pre-transformation version.

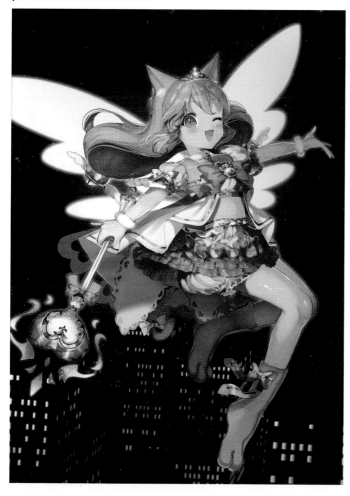

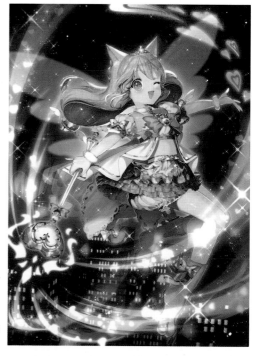

▶ Since the magical effects have increased as well as the amount of light striking the character, add more shine to the character's outline.

Young Demon Swordsman Illustration

With the full moon in the background, a young demon swordsman is floating in the sky while smiling mischievously at the viewer. We'll be walking you step by step through completing this striking illustration for a mobile game character.

Illustration by **Somemiya Suzume**

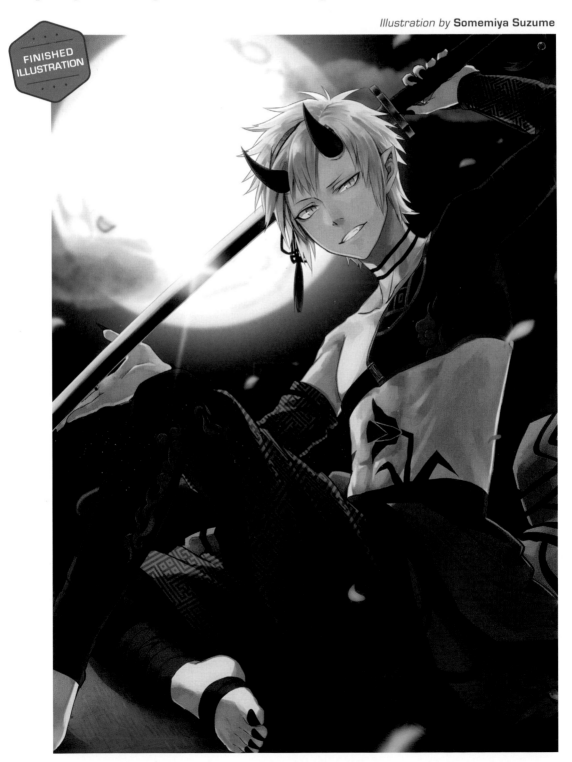

FINISHED ILLUSTRATION

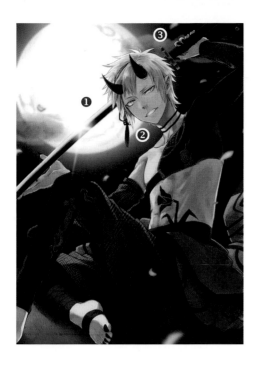

① A composition that guides your eyes

② Include a unique setting

③ Add in elements you personally enjoy

CHARACTER
Young two-horned demon swordsman

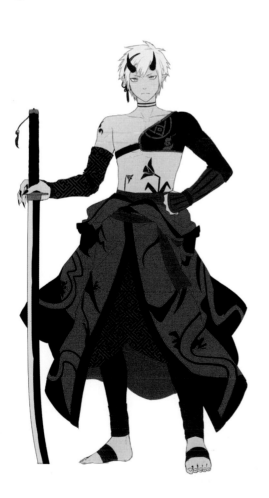
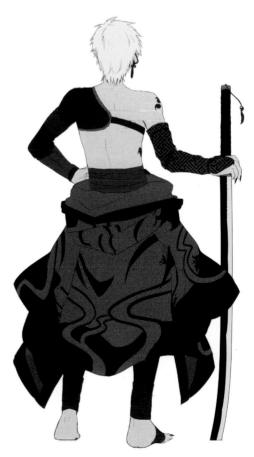

Organize Your Information Using Chibis

Using the character's personality as a base, think about his features and appearance. When designing the character's look, we'll be integrating chibi-style designs into the process.

■ COMMISSION ORDER FOR THE CHARACTER'S IMAGE

- A young male horned demon
- Wide eyes
- Has a demonic weapon

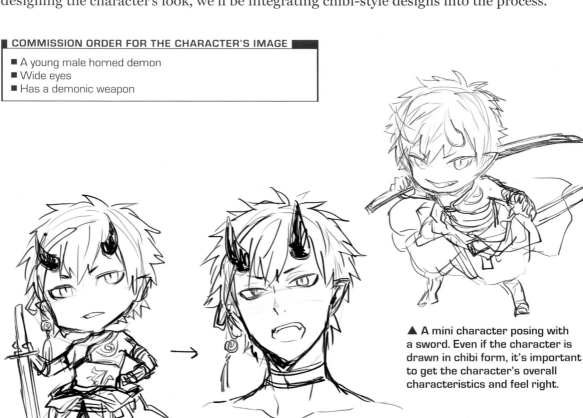

▲ A mini character posing with a sword. Even if the character is drawn in chibi form, it's important to get the character's overall characteristics and feel right.

◀▲ Design a mini character, then stretch the head and body. It's helpful for understanding the character's overall silhouette.

Since we designed the character's overall appearance using his chibi form, we'll add a chibi face.

◀▲ Draw various facial expressions. Even cool characters can have cute or surprising expressions.

Expanding on the Chibi Design

Now it's time for the fun part: adding the accessories and distinguishing details that make your character stand out.

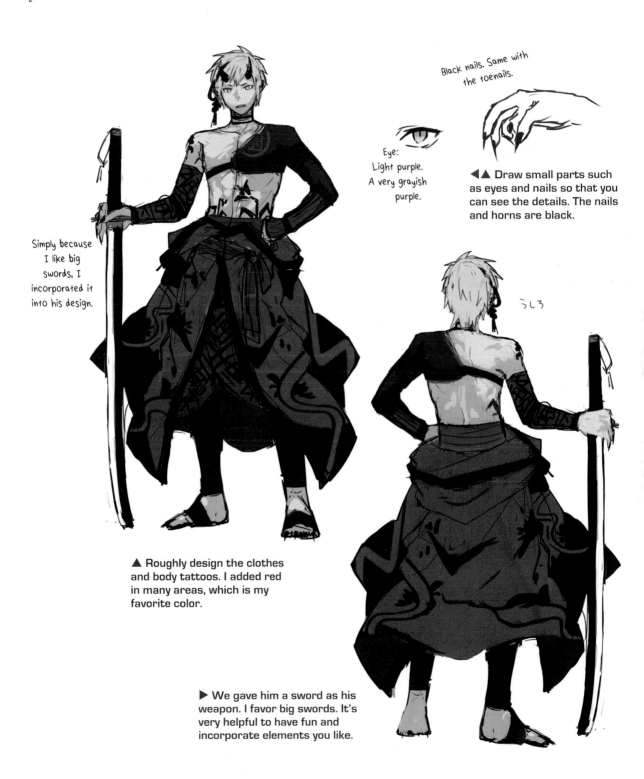

Black nails. Same with the toenails.

Eye:
Light purple.
A very grayish purple.

◄◄ ▲ Draw small parts such as eyes and nails so that you can see the details. The nails and horns are black.

Simply because I like big swords, I incorporated it into his design.

▲ Roughly design the clothes and body tattoos. I added red in many areas, which is my favorite color.

▶ We gave him a sword as his weapon. I favor big swords. It's very helpful to have fun and incorporate elements you like.

Think about His Personality and Make an Expression Chart

Since we've decided on the character's appearance, next let's think about his personality, sketching out the range of expressions that bring him to life.

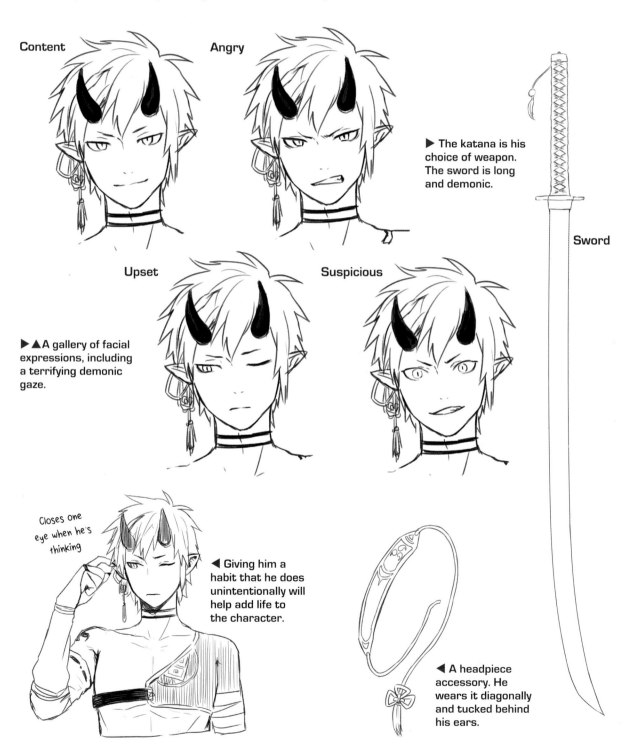

Content

Angry

▶ The katana is his choice of weapon. The sword is long and demonic.

Sword

Upset

Suspicious

▶▲A gallery of facial expressions, including a terrifying demonic gaze.

Closes one eye when he's thinking

◀ Giving him a habit that he does unintentionally will help add life to the character.

◀ A headpiece accessory. He wears it diagonally and tucked behind his ears.

Clean up the Line Art and add More Details to the Character's Setting

Sketch out a full-body draft and clean up the lines for the completed line art. Since the thickness of the line for the rough sketch and line-art versions is different, it can completely change the feeling of the illustration.

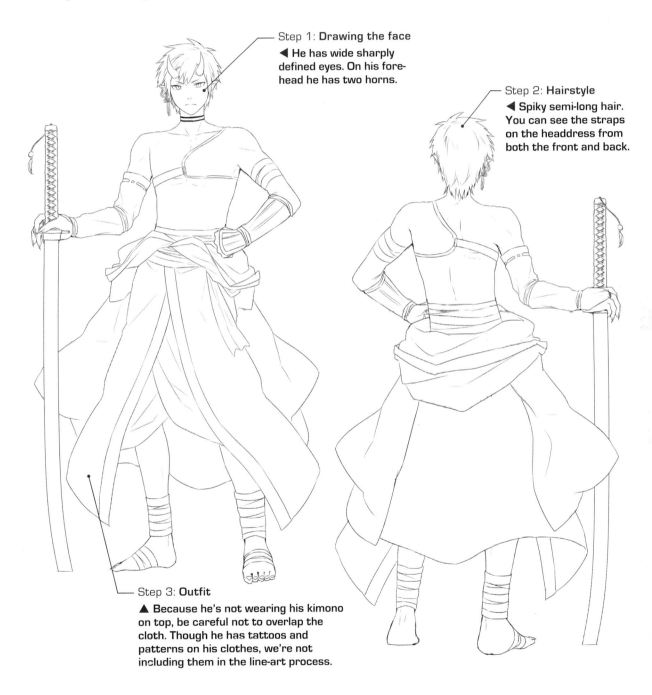

Step 1: **Drawing the face**

◀ He has wide sharply defined eyes. On his forehead he has two horns.

Step 2: **Hairstyle**

◀ Spiky semi-long hair. You can see the straps on the headdress from both the front and back.

Step 3: **Outfit**

▲ Because he's not wearing his kimono on top, be careful not to overlap the cloth. Though he has tattoos and patterns on his clothes, we're not including them in the line-art process.

Finish the Character's Design with Some Colors

Add color to the finished line art, including the patterns on the clothes and his tattoos. Since the patterns are on a curved surface, keep that in mind when adding them to the illustration. Try to bring out the character's image without adding any shadows.

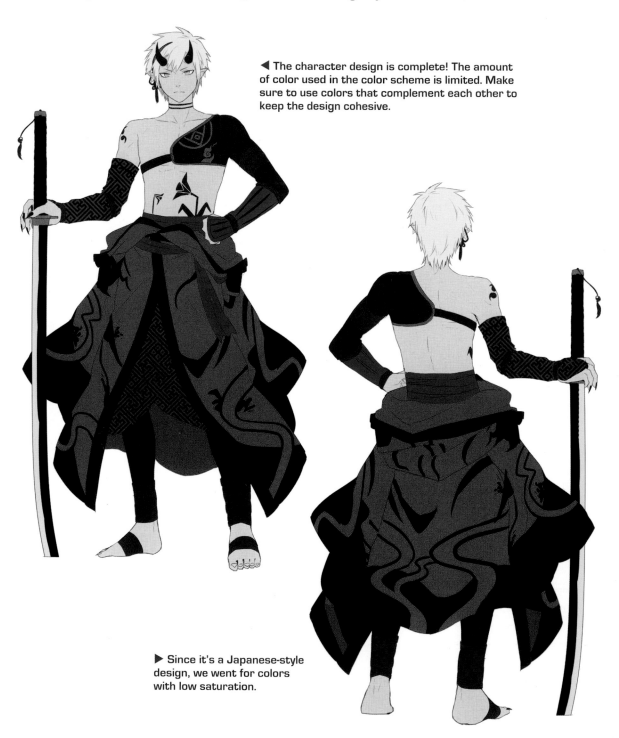

◀ The character design is complete! The amount of color used in the color scheme is limited. Make sure to use colors that complement each other to keep the design cohesive.

▶ Since it's a Japanese-style design, we went for colors with low saturation.

\boxed{\begin{smallmatrix}\text{MAIN}\\\text{PROCESS}\end{smallmatrix}\ \textbf{01}} Rough Sketch

Now it's time to think about the character's pose for the illustration. There are endless possibilities, so consider various possibilities until you find a pose and composition that suit you best.

┃ COMMISSION REQUEST ┃
- Convey the coolness of the character
- Create an eye-catching composition
- Make the standing pose unique

▶ A young demon with silver hair. He's not a one-horned hybrid, but an average two-horned demon.

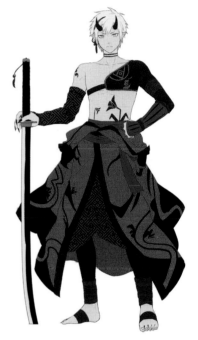

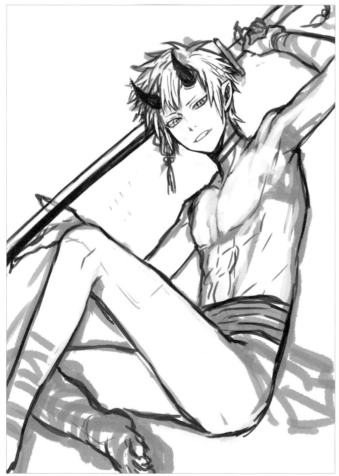

▲ After researching different characters posed with a sword, we went with this composition.

▶ This composition is similar to the pose drawn with a chibi-style character. There is a mischievous atmosphere to it.

45

Creating Line Art from the Rough Sketch

Add base colors to the line draft. You don't need to add shading at this stage since it'll be added later. The details of the setting and the clothing can be returned to later as well.

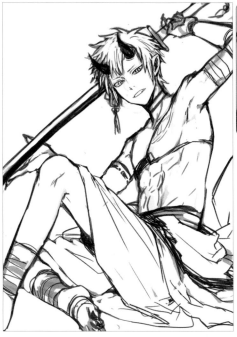

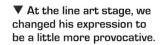

◀ The line art consists of thinner lines than the rough. Be careful not to change the illustration's overall impression.

▼ At the line art stage, we changed his expression to be a little more provocative.

▲ Even if these lines are not used in the final drawing, it's an important step to solidify the rough sketch to the finished product.

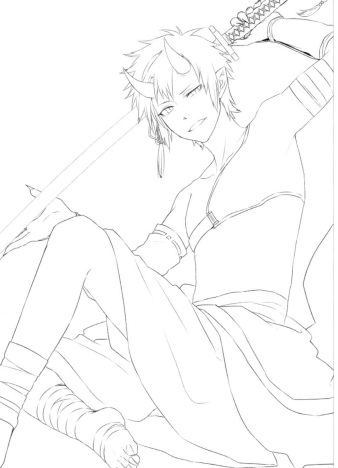

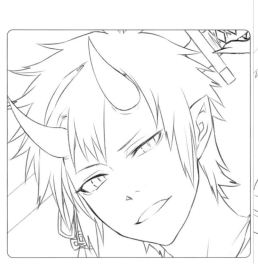

▲ Continue drawing while erasing the rough sketch lines.

Filling in the Character's Color Scheme

Now it's time to spin the color wheel and see which scheme best sets the mood and tone of the scene. Adjustments and refinements can be made later, but for now, it's time to paint!

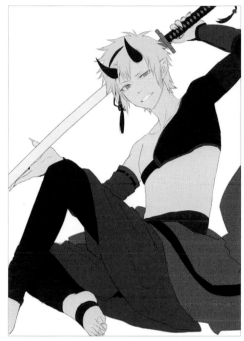

◀ Pay special attention to areas where a garment overlaps.

▲ Don't get lost in the details: always look at the big picture for proper color balance and tone.

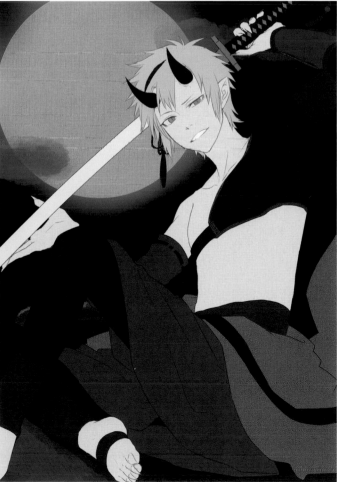

▲ Layered, darker tones can present a challenge.

▶ Don't forget the background for highlighting and framing your character.

Finalizing the Character and Background

Now that the character and background have been primed, it's time to paint in the details. Since the moon is bright and is also a light source in this illustration, be conscious of the play of shadows and light.

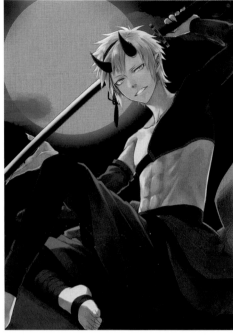

◀ Add dimension to his abdominal muscles by using complementary colors.

▲ The character is painted. We haven't added the tattoos or the patterns on his clothes, but we've introduced dimension by shading in the wrinkles.

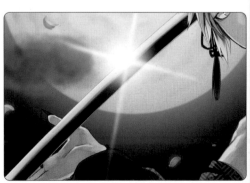

▲ Adding scattering petals to create an emotional atmosphere.

▶ In addition to the patterns on the clothes and body, other details such as craters are drawn on the full moon.

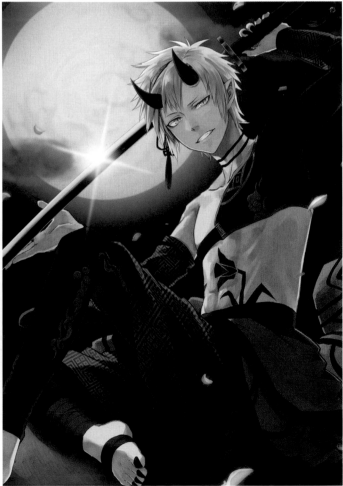

Adjusting the Color Balance and Solidify the Overall Impression

Once you're done painting the illustration, all that's left is to make fine adjustments. Work on solidifying the first impression the illustration gives. Add some shine to make the full moon and character more vivid. Finally, complete the illustration by adding a fence behind the character.

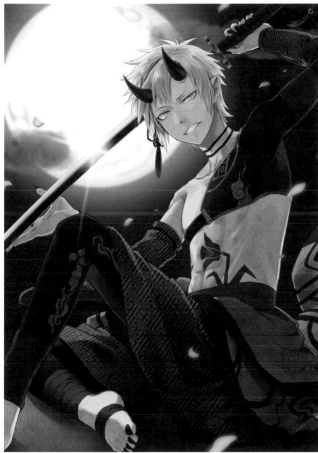

▲ Make the full moon shine to enhance the contrast with the character.

▲ We added a glowing effect to the background and the character to make them stand out more.

▼ Further adjustments have been made to tone down the redness. Add a fence behind the character and you're done!

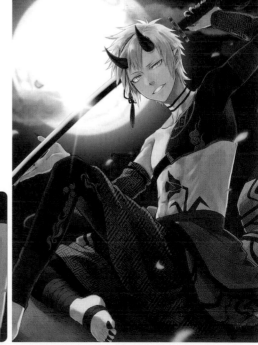

▶ Blur elements that are in front of and behind the character.

Powerful First Impressions
Adventurer Boy Illustration

For mobile game illustrations, RGB colors are often used to give the illustration vibrancy. Even with characters with a neutral color scheme, you can use vibrant colors to make the illustration pop!

Illustration by **Shigaraki**

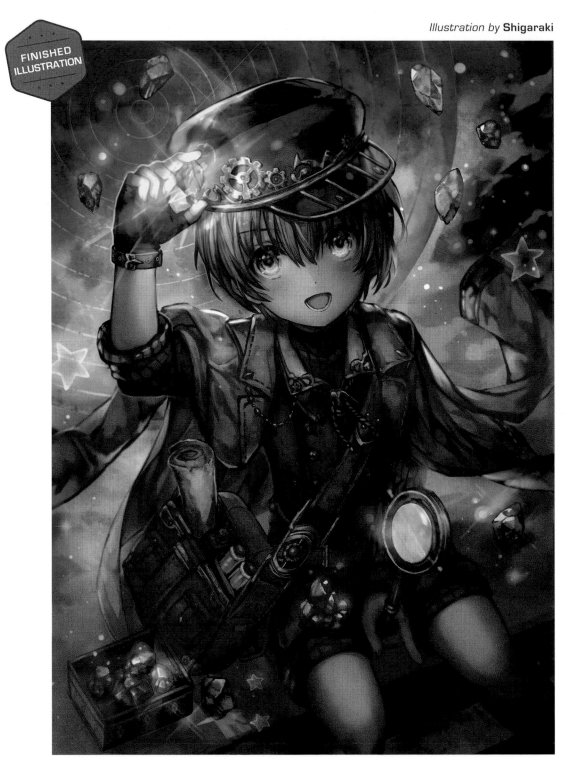

FINISHED
ILLUSTRATION

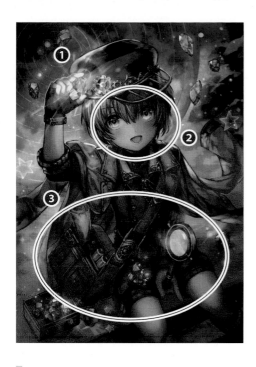

① Brighten the screen with a light effect

② Use a facial expression that conveys the character's personality

③ Add appropriate props and accessories

CHARACTER
Young adventurer

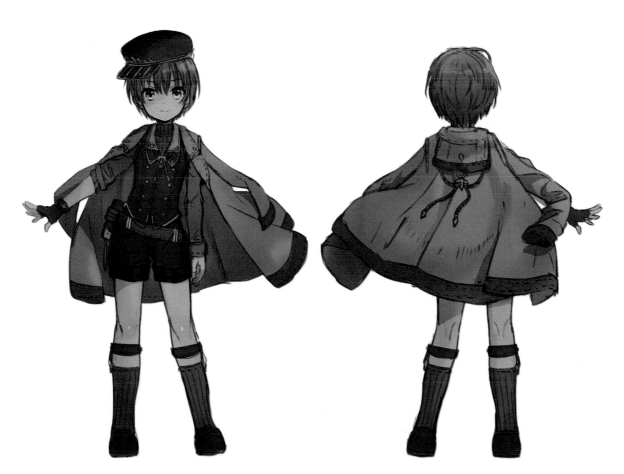

Rough Design of a Young Boy

Now we'll design a full-body character for a mobile game. Think about the type of features you can give the character so that the players are able to read the character's personality at a glance.

COMMISSIONED CHARACTER'S IMAGE
- Steampunk world with fantasy
- An adventurer boy who is a treasure hunter
- Victorian-style clothes
- A costume that reveals his legs

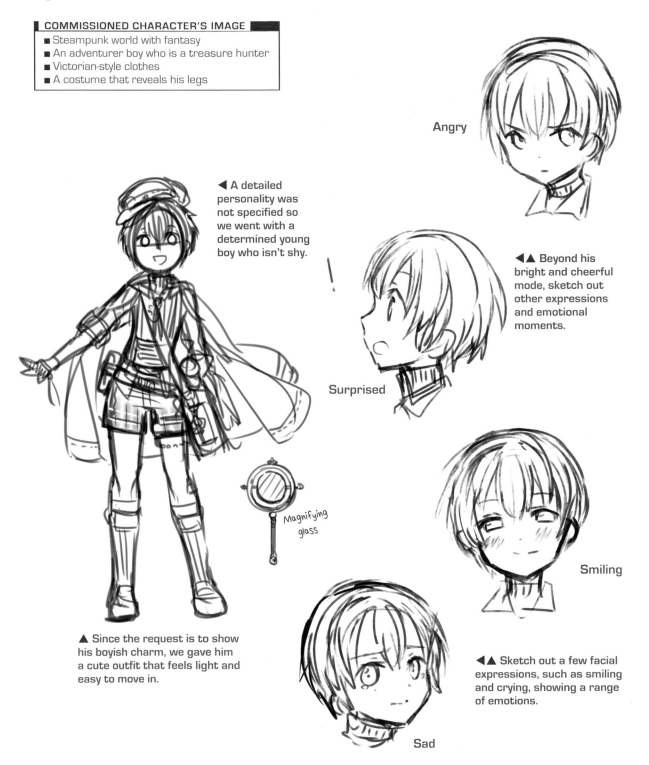

◄ A detailed personality was not specified so we went with a determined young boy who isn't shy.

Magnifying glass

Angry

◄▲ Beyond his bright and cheerful mode, sketch out other expressions and emotional moments.

Surprised

Smiling

▲ Since the request is to show his boyish charm, we gave him a cute outfit that feels light and easy to move in.

◄▲ Sketch out a few facial expressions, such as smiling and crying, showing a range of emotions.

Sad

Expanding the Design by Thinking of Various Poses and Small Items

Now that you've finished designing the character's full body, add on some elements so that players can grasp the character's personality and role at a glance. Think of some poses that match the character's story.

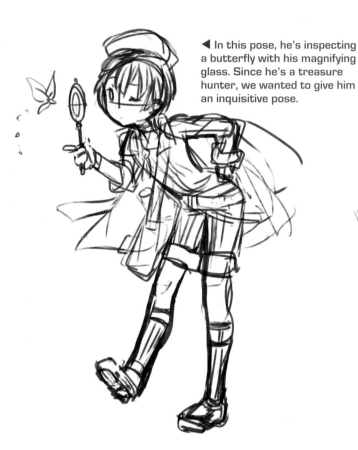

◀ In this pose, he's inspecting a butterfly with his magnifying glass. Since he's a treasure hunter, we wanted to give him an inquisitive pose.

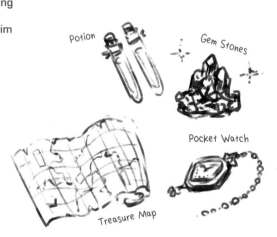

Potion

Gem Stones

Treasure Map

Pocket Watch

▲ The items that are always in the bag are the magic potions, gemstones, a treasure map and a pocket watch.

▶▼ A magnifying glass and a basic bag: since the character travels a lot, we kept it simple with not a lot of decoration to emphasize its practicality.

Magnifying glass

Bag

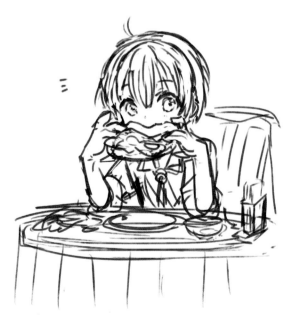

▲ He doesn't mind dining alone, but while eating, he's probably thinking about what to do if an acquaintance were to see him and say hi.

53

CHARA'S PROCESS 03 Design the Details and Clean It Up

Using the rough sketches made in the previous step, now add further details. Think about elements that will help bring out the character's personality and charm when sketching his costume and accessories.

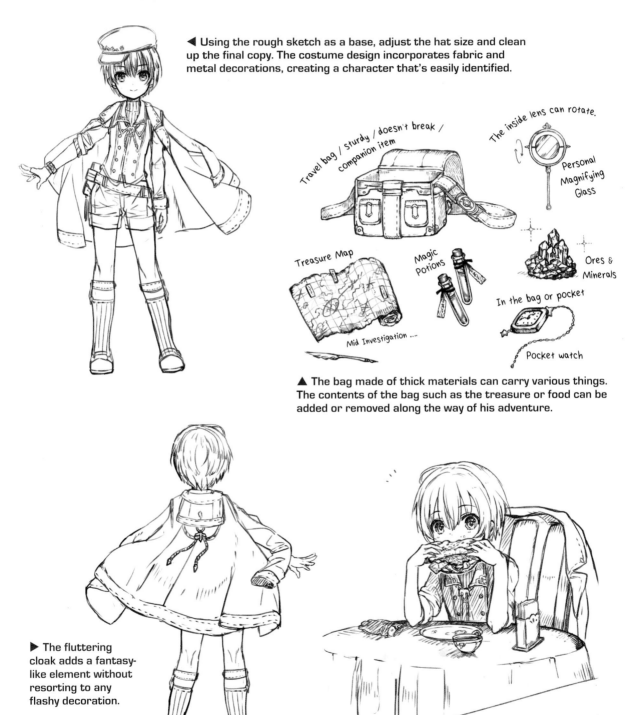

◀ Using the rough sketch as a base, adjust the hat size and clean up the final copy. The costume design incorporates fabric and metal decorations, creating a character that's easily identified.

Travel bag / sturdy / doesn't break / companion item

The inside lens can rotate.

Personal Magnifying Glass

Treasure Map

Magic Potions

Ores & Minerals

In the bag or pocket

Mid Investigation

Pocket watch

▲ The bag made of thick materials can carry various things. The contents of the bag such as the treasure or food can be added or removed along the way of his adventure.

▶ The fluttering cloak adds a fantasy-like element without resorting to any flashy decoration.

▲ Although he's a small boy, he's highly active so he eats a lot.

Facial Expressions and Color Scheme

Now decide on the character's color scheme and apply it to the full-body sketch. When deciding on a color scheme, think of one main color, then choose complementing hues to follow. We'll also add more details to the character's facial expressions to deepen our understanding of the character's personality.

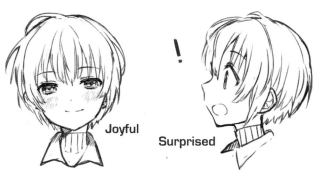

Joyful

Surprised

▲ His joyful expression has a mature feel, while his surprised expression is more childish and matches his age. The more you sketch out his expression, the more concrete it becomes and the nuances in his expression will become clearer to you.

▼ It's unlikely that you'll be using different facial expressions if the character is being used in one illustration, however, in recent mobile games, there are also dialogue sections and at times, different facial expressions are required. It's useful to create a chart showing the character's basic facial expressions such as angry or sad.

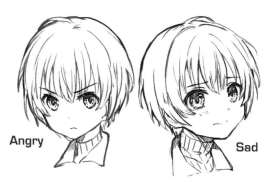

Angry

Sad

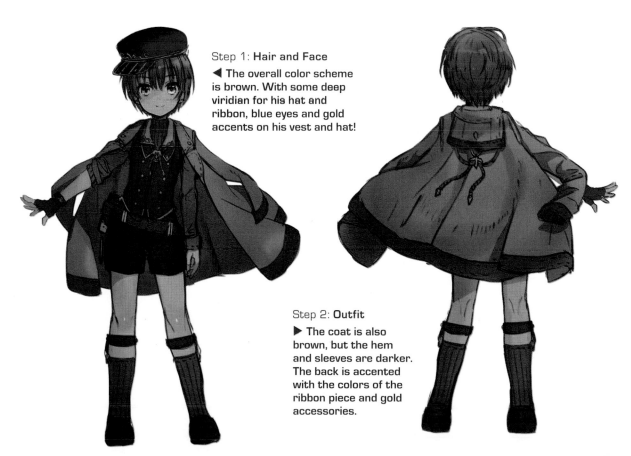

Step 1: **Hair and Face**

◄ The overall color scheme is brown. With some deep viridian for his hat and ribbon, blue eyes and gold accents on his vest and hat!

Step 2: **Outfit**

▶ The coat is also brown, but the hem and sleeves are darker. The back is accented with the colors of the ribbon piece and gold accessories.

Using the Character's Image to Create a Illustration Blueprint

Using the character designs, come up with a blueprint of your illustration. In order to be able to capture the character's charm at a glance, create a rough sketch including the various elements.

COMMISSION REQUEST

- Bright and vivid colors
- Character with a lot of accessories
- Clearly an explorer/treasure hunter

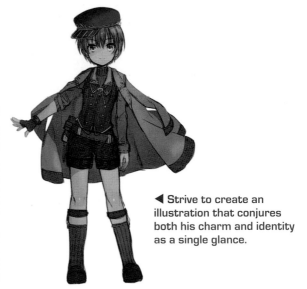

◀ Strive to create an illustration that conjures both his charm and identity as a single glance.

▲ The gems and magnifying glass complement this charming pose with his knees touching together.

▶ Similar to the sketch on the left, we played around with the composition and went for a high angle. From this vantage point, we can easily capture the beauty of the gemstone.

Rough Coloring and Line Art

Once you're done with the illustration's rough sketch, add the colors as well. In order to prep for the final coloring, roughly add colors based on the sketch, slowly cleaning it up along the way.

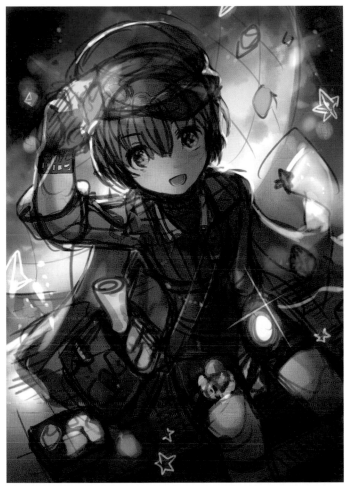

▲ We chose a low-light setting so that the vivid tones and hues of the gemstones pop and seize the viewer's attention.

▲ Based on the commission order of "bright and vivid colors," we'll roughly add the colors to the illustration. The steampunk clothing is less saturated, so use the surrounding gemstones to add bright colors to the illustration.

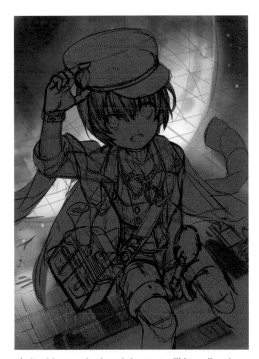

◀▲ To keep the color balanced, we add shiny elements, such as the gems and magnifying glass to the bottom of the screen. That way, the bottom side of the illustration isn't too dark.

▲ In this rough sketch layer, we'll be adjusting the lines to be closer to the final copy. Since these lines were used to mark the placement of the rough color sketch, we can fix them later after applying thicker lines.

Applying the Final Colors and Making Adjustments for the Final Form

Using the newly adjusted lines, add the final coloring. Refer to the full-body character design sketch you created to keep the character's colors cohesive.

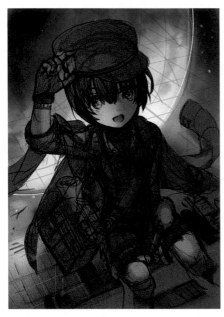

▲ Move the color rough layer over the line drawing and reduce the opacity so you can see the rough colors while applying the final colors.

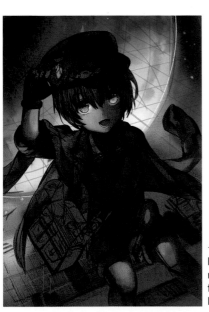

◀ Continue to add colors while being conscious of where the rough colors are. We'll also fine-tune each part such as the hat, eye angle and legs.

▲ Apply color while adjusting the shape of each part such as the right arm, torso, and lower body. The colors of each part has mostly already been decided for the final finish.

▲ The hat is decorated with metal designs such as gears to add to the steampunk image.

After Completing the Final Coloring, Add Some Highlights

Highlights are more than just sparkle and shine. Determine the light source, direction and intensity first before adding lustrous effects to the illustration. Balance is key!

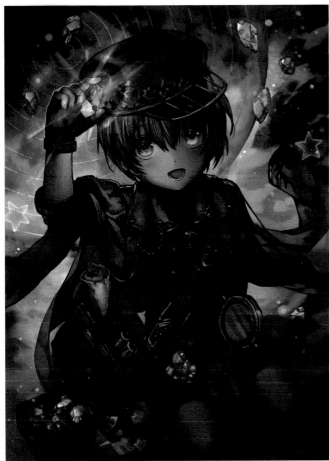

◀ We adjusted the angle of the face significantly to match with the composition and the background that was added. The overall composition hasn't changed, but the addition of the background depiction has greatly changed the atmosphere of the illustration.

◀▲ Add highlights to the metal decorations on the clothing and back to give them a glossy look. The gem shines are layered in dodge (linear) mode to give it the shiny effect.

◀ A strong ray system effect is added to the main ore held over the right hand with a layer in dodge (linear) mode. The striations are graduated in color and look natural when there is strength or weakness in the light. Here it's made even brighter, set at the highest brightness adjustment.

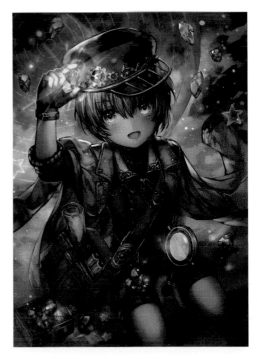

▶ Finally, think about the fact that this illustration is primarily viewed on a smartphone screen, so adjust the overall color to be brighter. While darkening the leg areas, this will draw the viewers eyes toward the areas that are shining.

Using Light and Shadow
Seamstress Illustration

For this section, we'll be walking you through the process of designing a seamstress character for a mobile game. We'll discuss how to design characters with unique personalities and point out what to look for when working on mobile game illustrations.

Illustration by **Tomari**

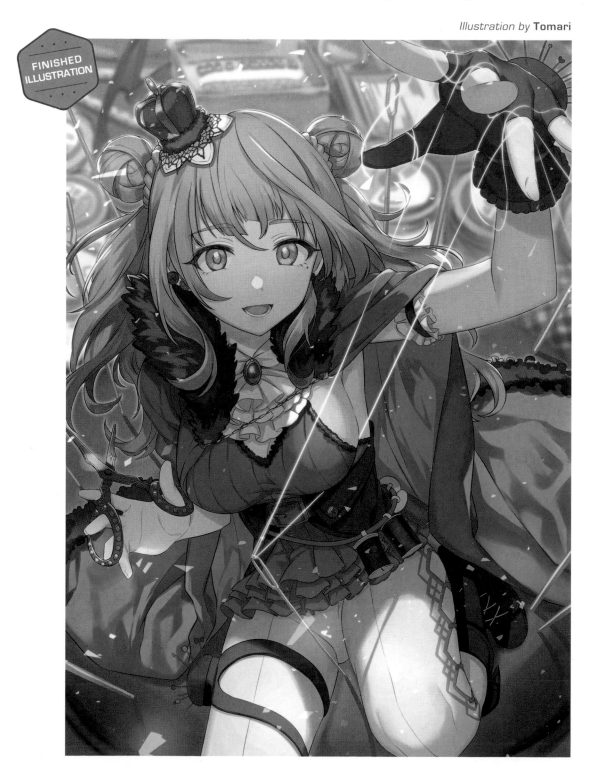

FINISHED ILLUSTRATION

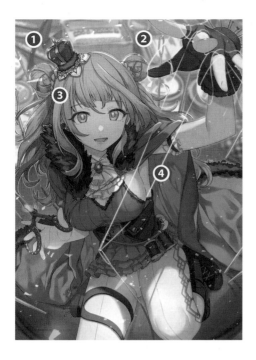

① Keep the resolution and icon usage in mind

② Incorporate one or more unique character traits

③ Focus on the eyes and hair

④ A dynamic, powerful pose over all

CHARACTER
A female fighter who uses sewing tools

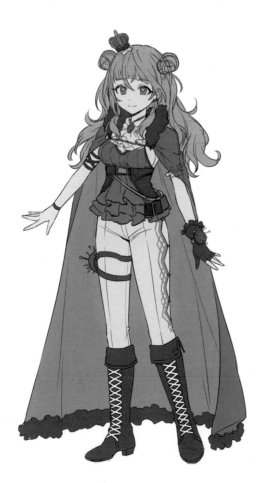

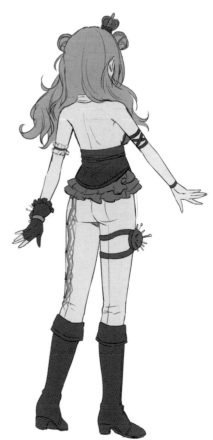

Think of a Silhouette with Personality

Think about the general shape of the character's individual body parts and assemble them into a full-body silhouette. The individuality shines through just from the basic silhouette. You can express the individuality through the silhouette by adding the hairstyle and accessories.

COMMISSION REQUEST

- Young woman in her late teens
- Despite her charm, she's actually cruel
- Outfit is solid-colored
- Carries creative fighting tools and implements

▶ Make the design paying attention to the silhouette of the whole body. Bring out the individuality by incorporating the uniqueness of the character.

Having a ball of yarn in mind when drawing the bun

▲ Her hairstyle is pulled up in a bun resembling a ball of yarn.

▼▶ Pincushions are attached to the thighs of the left wrist and right leg so that the needles can be easily accessed.

Needle rig

▶ The scissors, which serve as both a sewing tool and a weapon, give her a menacing impression.

Button Earring

▲ Button type earrings. Add the character's characteristics to the details to create a sense of unity.

The thread is suspended via loop.

▶ Thread is used by hanging a spool with a ring on the body.

Expand the Rough Design

Now that you have a rough idea of the character's overall look, think about her face, hairstyle and outfit. Once you're finished with the design, create her full-body line art. Make sure the image you had in mind doesn't get lost in the process.

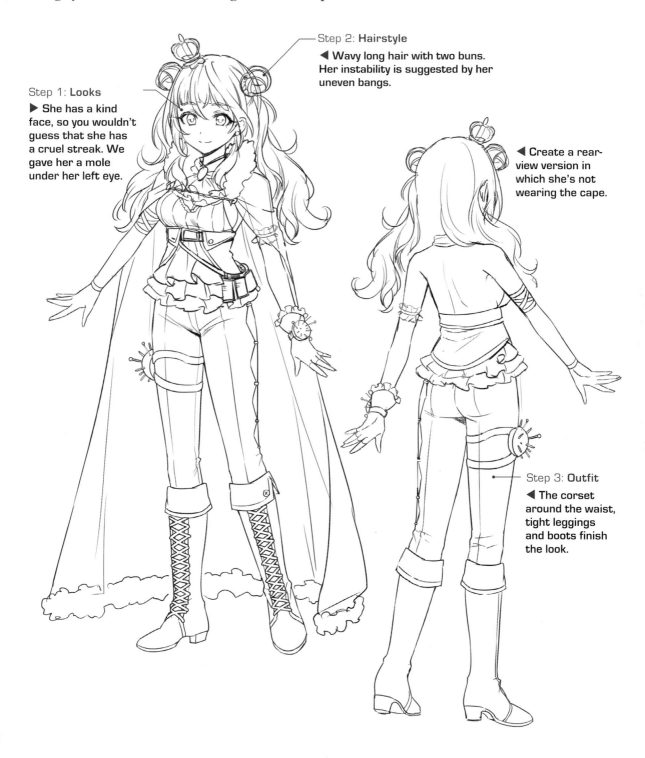

Step 2: Hairstyle

◀ Wavy long hair with two buns. Her instability is suggested by her uneven bangs.

Step 1: Looks

▶ She has a kind face, so you wouldn't guess that she has a cruel streak. We gave her a mole under her left eye.

◀ Create a rear-view version in which she's not wearing the cape.

Step 3: Outfit

◀ The corset around the waist, tight leggings and boots finish the look.

Creating an Expression Board

Now that you've completed the character's look, think about her personality and range of expressions. Sketch a few different expressions that'll match her moods. Try drawing them from different angles.

Joy

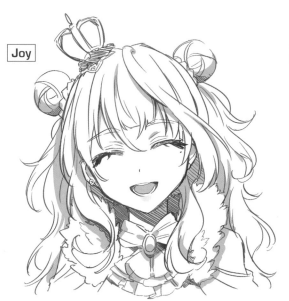

▲ Her expression of joy. Her eyes are closed and she smiles with an open mouth while tilting her neck.

Sadness

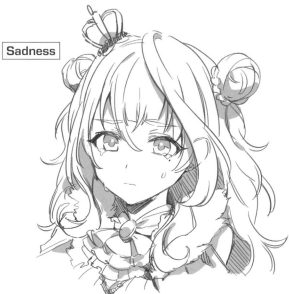

▲ Her expression of sadness. She's so sad that she couldn't hold back her tears.

Surprised

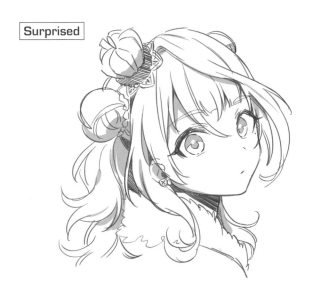

▲ Her surprised expression while looking backward. Pose the character to your preference.

Anger

▲ Her anger expression makes her raise her chin and look down. Anger often shows someone's true form.

Adding Color

Now add color to the full-body character sketch. To make sure the character's design looks cohesive, limit the number of colors used in the overall scheme.

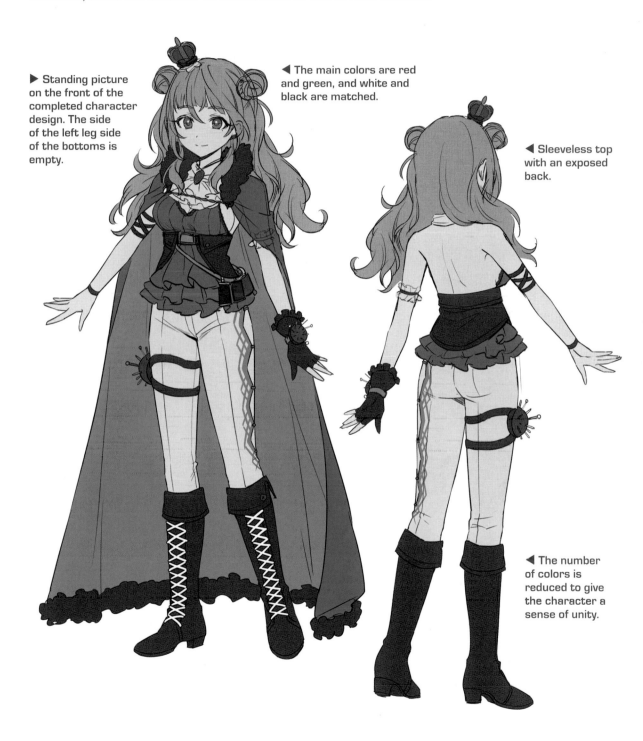

▶ Standing picture on the front of the completed character design. The side of the left leg side of the bottoms is empty.

◀ The main colors are red and green, and white and black are matched.

◀ Sleeveless top with an exposed back.

◀ The number of colors is reduced to give the character a sense of unity.

From Character Design to Illustration Rough Sketch

Now that we've completed the character design, let's use that design to create a rough draft of an illustration that'll match the character's image. Since this illustration will be used for a mobile game, make sure that the illustration is suitable for smartphone viewing and that it'll look good as an icon.

COMMISSION REQUEST

- Give her a refined glamour
- Capture the darkness that reflects her cruelty
- Show her attacking with a smile

▲ A seamstress-themed villainess, vicious beneath her seeming innocence.

▶ Her right hand holds the scissors while the left pulls the thread. It gives her a mysterious quality.

MAIN PROCESS 02 From Line Art to Rough Colors

In this step you'll be adding more details to the rough sketch to refine the illustration. Then work on the line art, making sure the overall effect isn't lost in the process. Be especially careful around the face area.

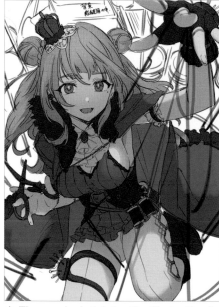

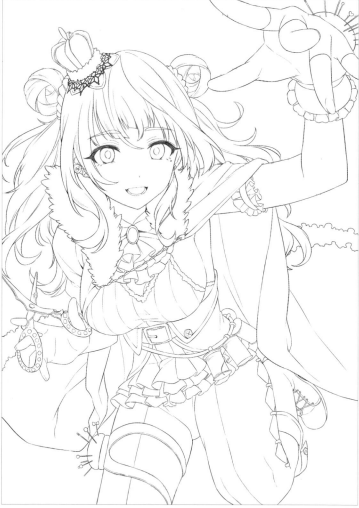

◀ Draw the sketch lines for the threads.

▲ The rough sketch for the illustration is colored. The background is the contents inside a sewing box.

▲ The momentum of each section is expressed through the thickness of each line stroke. Give the strokes variations.

▶ This is the line-art version for the character. The flow of her hair and the wrinkles on her clothes add dimensional effects.

67

Add Details to the Background and Finalize the Coloring

Once you've cleaned up the character sketch, make the background blurry and the threads visible by giving them bright colors. Finally, make adjustments to the overall color of the illustration!

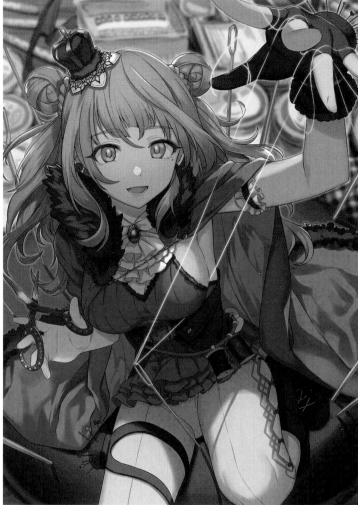

◀ Since we've decided to make the character's personality a little dark, add more shadows to match her personality. We also added shadows to her eyes.

▲ In the background there are tools you'll find in a sewing box, such as pins and needles.

▼ The atmosphere can be heightened by adding light reflections spread throughout the screen.

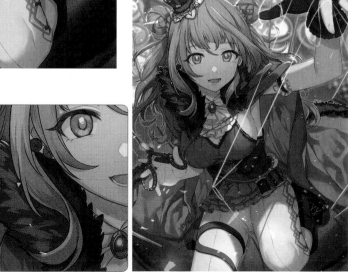

▶ Reflection effects have been added throughout the character's body but not to her face.

CHAPTER 3
Character Design for Illustrations

How to Draw Character Illustrations

Character illustrations are ever in high demand. Here we'll use various media, platforms and formats as examples to introduce the points you should keep in mind when creating and developing an illustration.

In order to create a character illustration

- Think about various compositions
- Include theme and elements you want to bring out
- Highlight elements you want to focus

Since the illustration will become the "face of the product," it's important to include that product's theme or defining elements that'll grab the target audience's attention the most. Since these illustrations are commissioned, you'll have to keep the specifications and request in mind. Therefore, it's effective to have several versions of the composition rough sketch so that you can make comparisons. This will ensure a smooth process to address your client's changing needs.

◀ This degree of roughness is enough to understand the pose, body shape, camera angle and background elements. So if you make multiple versions of the rough sketch, it'll be easier to organize your thoughts.

▶ Try to incorporate elements to match the work's theme such as jewels for a phantom thief and fashionable clothes for a covergirl.

Think about Pose and Composition

- Direct the character's gaze to the reader
- Add movement to the illustration
- Create a composition that's simple and easy to understand the situation.

As discussed on page 20, if the character is looking at the viewer, a stronger connection is created. If you add moving elements to the illustration, that will also seize the viewer's attention. However, if the illustration is too elaborate and complicated, it'll become unclear what you're trying to convey. It's important to keep it simple so viewers can understand the situation at a glance.

▶ The character's effectively devised if the pose and composition are designed so that the viewer can immediately understand the situation and is directly engaged by the character. By having a character offer food and establish eye contact, an immediacy and intimacy are established.

◀ Even in a cafe that usually has a calm and quiet atmosphere, you can create a composition that adds movement, such as raising steam, flowing liquid and props flying in the air. This dynamism and motion make the illustration much more interesting for the viewer.

Things to keep in mind when working with print illustrations

- Don't place important elements on the edges or bottom of the screen
- Leave space for text

For media such as books and posters, multiple images are printed on a large piece of paper. After that the proof is cut into individual pages and often trimmed to size. In the case of an illustration for a book cover, there's often promotional phrases that accompany the illustration as well. These phrases are generally placed near the bottom. So when designing the illustration, arrange it so that important elements, such as the character's face, are not in the areas where text may be placed.

▲ Generally, the cover designer will arrange the text so that it doesn't block the character's face. However, it's important to keep in mind where text is often placed in advance so you can design the ideal illustration.

▼ The character's face is placed in the upper-center area because here the title of the work will be placed on the left and right sides, as well as in the band on the bottom.

Useful Character Design Advice

Read the draft until the image comes out
Before designing, first of all, I formulate a vague sense of the original plan in my mind. Read the commission request repeatedly until inspiration strikes, then look for reference materials for each element such as face, clothes, hairstyle and accessories to make the image concrete. I think it's important to stay aware of trends and to gather reference materials on a regular basis. (Yuki Sakura)

Collect reference material
Collect as much reference material as you can, such as the various decorations and clothing designs that catch your attention more. I have my own taste, but I don't know what I'll be asked to produce when I get a commission, so I collect a range of resources, from multicultural to mechanical, modern clothes, fantasy, anything that inspires you. By doing so, you will be able to pull the design from a variety of influences and inspirations, thus elevating the end result. (Shigaraki)

Draw anyway to increase motivation
Don't think too much; it's important to try drawing automatically and let you hand lead the way. If I overthink my process or overplan the stages of character development, I find it hard to execute or follow through. The character can also be stiff as a board, so I think it's important to be in the mood when you're drawing. (Yotoi)

Combining my taste and trendy design
I get many requests to draw teenaged girls, so the transformation animation I saw in the past is very helpful. It's very important to adopt the designs that are popular now, so I think it's best to look at the illustrations of various people and study what kind of design is currently popular. I strive to create an effective combination of trendy designs and my favorite designs. (Moshiki)

Increase your knowledge
I think it's important to increase your knowledge of various fields when devising a character. It'll make the designing process easier if you write down what you like about a design and organize it in folders so you can access them immediately. (Tsubata Nozaki)

Rely on the Internet to research what you're interested in
I am keenly aware of the importance of collecting information. Most of the images and descriptions of small items related to my characters can be found on the Internet, so I try to investigate and draw the specific items and objects I'm interested in including. (Tomari)

Collect images you think are good
I think it's a good idea to collect various images that you like, such as your favorite singers, actors and anime drawings. On days I lack inspiration, I often get ideas from consulting those images I saved. (Suzume Somemiya)

Make a note of the ideas you came up with
There are many characters our there in the world, so I usually think about ways I can make my characters stand out among them. I think it's a good idea to make notes of the ideas that pop into your head. They'll definitely be useful later. (DS Mile)

Check out fashion magazines
If you look at fashion magazines, you'll find a wide range of designs to inspire you and to choose from. It's fun to check out the photo spreads. Even if you don't want to subscribe to or purchase these resources, just look at the covers or check out a celebrity fashion feature online and see what ideas and which designs you wish to "borrow." (Atsuki Ogino)

Shining in the Spotlight
Idol Illustration Used for Poster

In recent years, idols and pop princesses are a popular character in anime and games. The way to create an appealing character is to fuse three aspects: appearance, gesture and outfit!

Illustration by **sophie**

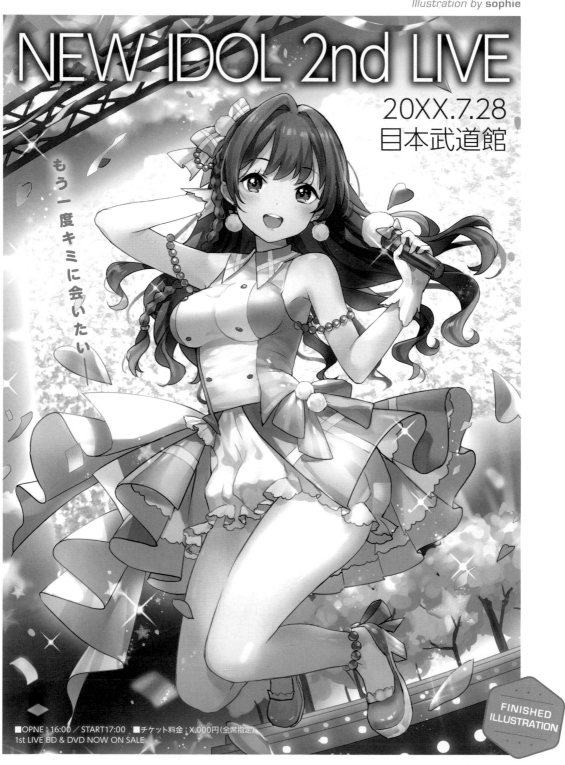

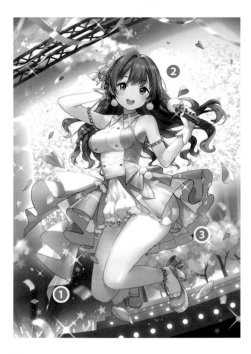

KEY POINTS

① Capture the glamorous atmosphere of the live stage

② Bring the character to the front

③ Grab the viewer's attention throughout the entire illustration

■ CHARACTER
A pop star with an infectious smile

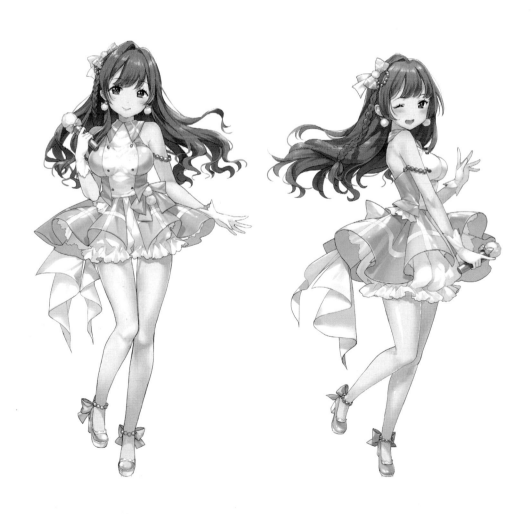

From Imagining a Young Female Idol to Rough Sketch

The most important point to consider when developing an idol character is instant recognition. Be sure to incorporate pop star elements into her outfit, accessories, and even her pose.

CHARACTER'S IMAGE PER COMMISSION ORDER
- Female idol in her early 20s
- Long hairstyle
- She's the lead singer of the group
- Both stylish and appealing

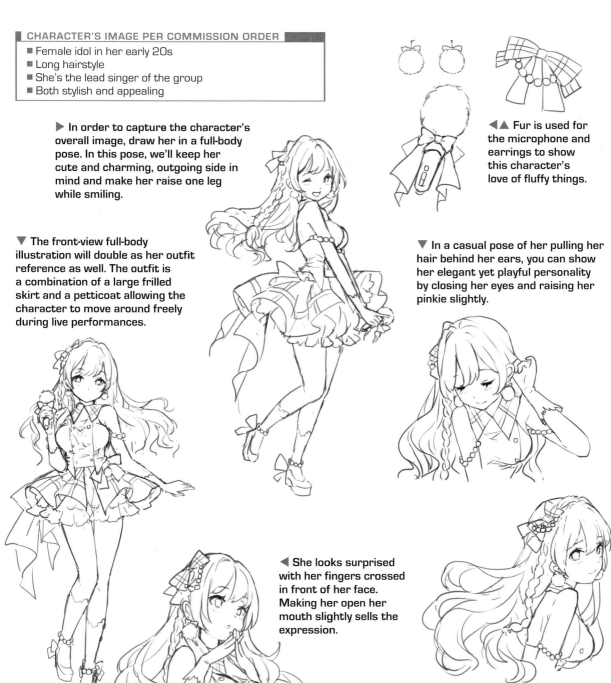

▶ In order to capture the character's overall image, draw her in a full-body pose. In this pose, we'll keep her cute and charming, outgoing side in mind and make her raise one leg while smiling.

▼ The front-view full-body illustration will double as her outfit reference as well. The outfit is a combination of a large frilled skirt and a petticoat allowing the character to move around freely during live performances.

◀◀▲ Fur is used for the microphone and earrings to show this character's love of fluffy things.

▼ In a casual pose of her pulling her hair behind her ears, you can show her elegant yet playful personality by closing her eyes and raising her pinkie slightly.

◀ She looks surprised with her fingers crossed in front of her face. Making her open her mouth slightly sells the expression.

▲ When she's about to cry, raise her shoulders a little. By drawing multiple expressions from different angles, you can solidify the character's full appearance.

Add Colors to the Sketch to Deepen the Character's Design

Now that you're done with the rough sketch, it's time to deepen your understanding of the character even further. Come up with a color scheme and apply it to the rough sketch. This will help bring balance to the overall palette once you work on the final illustration.

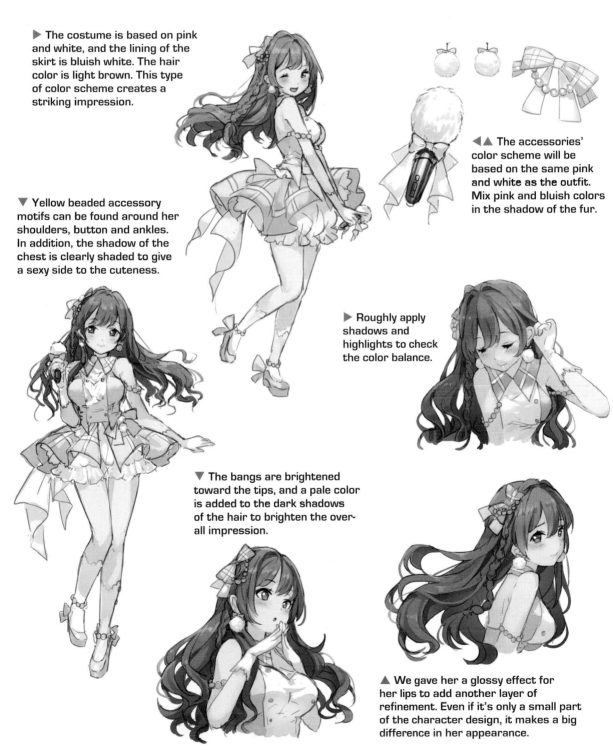

▶ The costume is based on pink and white, and the lining of the skirt is bluish white. The hair color is light brown. This type of color scheme creates a striking impression.

◀▲ The accessories' color scheme will be based on the same pink and white as the outfit. Mix pink and bluish colors in the shadow of the fur.

▼ Yellow beaded accessory motifs can be found around her shoulders, button and ankles. In addition, the shadow of the chest is clearly shaded to give a sexy side to the cuteness.

▶ Roughly apply shadows and highlights to check the color balance.

▼ The bangs are brightened toward the tips, and a pale color is added to the dark shadows of the hair to brighten the overall impression.

▲ We gave her a glossy effect for her lips to add another layer of refinement. Even if it's only a small part of the character design, it makes a big difference in her appearance.

75

Make an Expression Chart

Once the overall character design has been completed, create an expression chart to show the character in various situations. Facial expressions can be a challenging element where the nuance can change slightly, so try out various versions.

Shy
Color her cheeks red to show that she's blushing and quite close her mouth. She looks like she has something to say but can't say it.

Angry
In order to express her mounting anger, raise her eyebrows but turn her eyes away.

Pensive
The eyes are hollowed out and the mouth is drawn small to give her a dreamy yet calm expression.

Laughing
To bring out the brightness in the expression, draw her smile big as if she's laughing without any concerns.

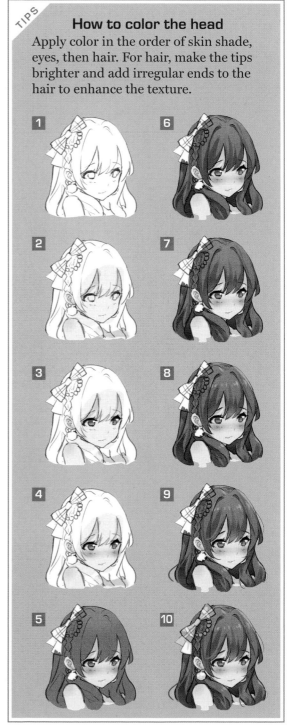

TIPS

How to color the head
Apply color in the order of skin shade, eyes, then hair. For hair, make the tips brighter and add irregular ends to the hair to enhance the texture.

Creating the Line Art and Adding Base Color

While balancing the overall proportions, make a clean copy of the rough sketch. However, if you follow the rough sketch too precisely, the line art may end up looking stiff. So use the rough sketch just as a reference while moving on to the next stage.

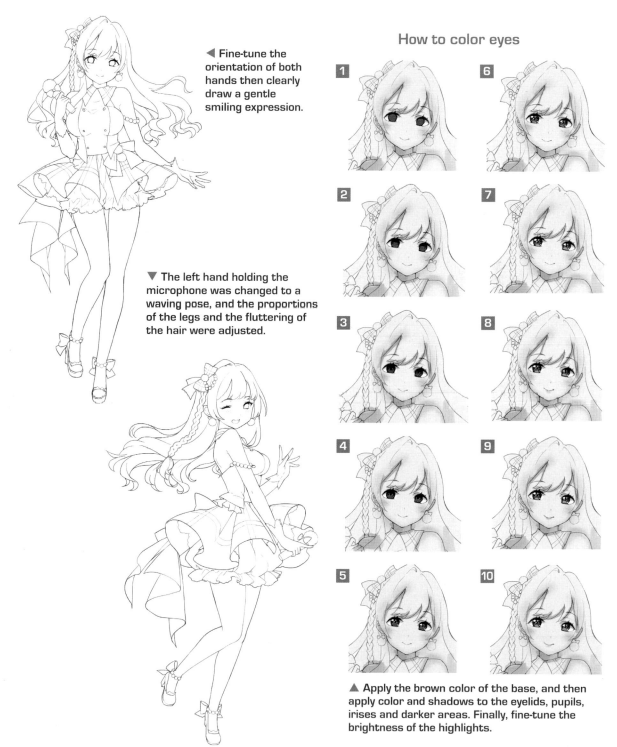

◀ Fine-tune the orientation of both hands then clearly draw a gentle smiling expression.

▼ The left hand holding the microphone was changed to a waving pose, and the proportions of the legs and the fluttering of the hair were adjusted.

How to color eyes

1 6

2 7

3 8

4 9

5 10

▲ Apply the brown color of the base, and then apply color and shadows to the eyelids, pupils, irises and darker areas. Finally, fine-tune the brightness of the highlights.

77

CHARA'S PROCESS 05 Adjust the Colors and Bring out the Accents

Now it's time to paint the full body. Give priority to her skin and eyes, then the other areas that make up a majority of the character such as her hair and outfit. Then apply accent colors to the smaller, more detailed areas.

Apply a base to shade the skin

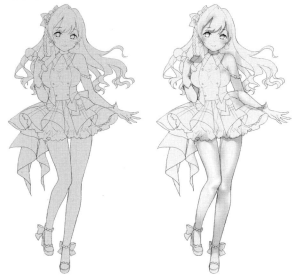

▲ Apply one color to create a base, and add highlights and shading to the skin of the face and limbs.

Apply hair and make fine adjustments

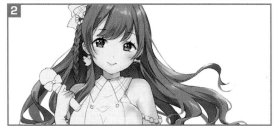

▲ Apply the basic color and shadows to the hair, and add bluish white to the dark shadows to prevent it from becoming too dark. After that, add highlighting and draw the loose hair to finish.

Finish the costume separately

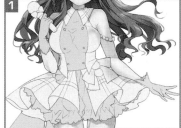
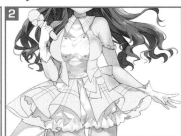
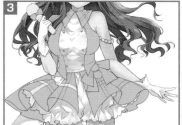

▲ Paint the white and pink parts of the costume separately. After painting with the base color, draw shadows according to each color.

Complete!

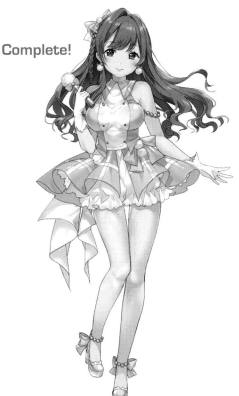

78

Composition for the Poster Illustration

Once the character is solidified, start working on the actual illustration. Come up with a compositional scheme while roughly adding elements such as the background and accessories. Think of a compositional design that brings out the character's charm and highlights her outfit.

COMMISSION ORDER

- A scene with a lot of movement at a live concert
- Overall image = gorgeous
- Make the character stand out with a pose that shows the whole body
- Turn the character's gaze straight at the viewer

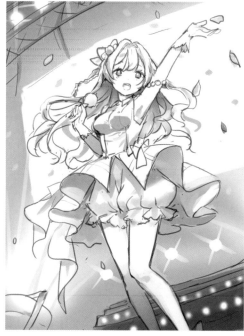

▶ While working on the final illustration, refer back to the sketches you previously made. It'll be easier to work with if you place your reference material in a position where it's visible and you can easily make comparisons.

Modified rough sketch

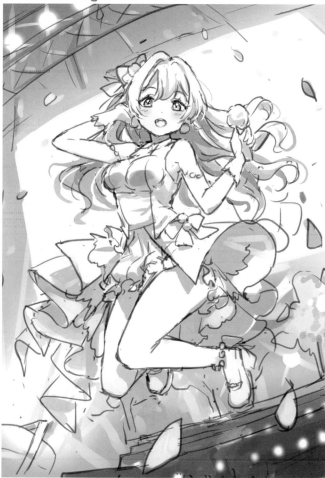

▲ Here we're using a modified rough sketch. This compositional scheme conjures a compelling moment when she's leaping into the air while the audience cheers. Bend her arm backward to create a more delicate pose.

First rough sketch

▲ With this pose, the star gestures to her adoring fans. The legs were modified to focus the attention upward.

Creating the Line Art and Adding Color While Being Aware of Text Space

Clean up the lines for the character, stage background and the fluttering hearts, and follow the same color process as when you colored the full-body character design. Notice that the fluttering of the hair, skirt and other details are fine-tuned at this stage.

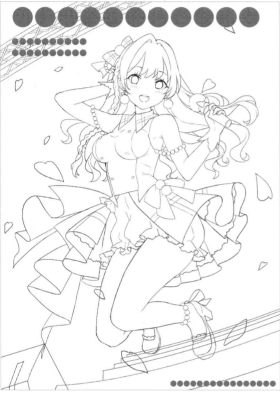

> **TIPS**
>
> ## Be aware of the space for text
>
> The concert poster will contain information about the event. In particular, the event name, date, performers and other relevant info will be set large so that they can be seen at a glance. So be sure to create two spaces for the text.

▲ Adjust the drawing of the whole body and bring the head and body into line. The skirt is also wavy so that the shape of the hem is more like a frill. Roughly place the mocked-up/dummy text and check if there is enough space to accommodate it.

◀▼ If you draw the truss (framework made of triangles) and the stairs in the background with a slightly curved line, you will get a wide-angle effect.

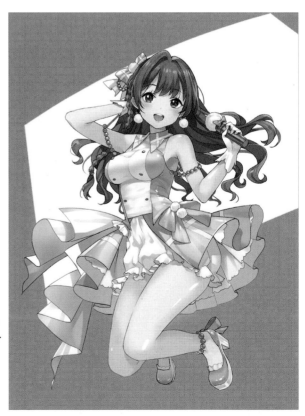

▲ Use the same procedure as on page 79. At this stage, the color of the background is not added yet, and the character is painted in the same color as the standing pose.

Adjust the Brightness and Color Saturation

Increase the brightness of the entire screen by introducing light-emitting elements. The point is to use bright colors for the background, such as placing the cherry blossoms on the stage and the blue sky at the top of the screen, so the background elements remain cohesive and balance with the character.

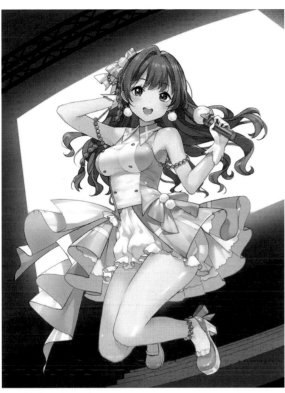

◀ Have the monitors in the back emit light to make the stage look like it's glowing. The same pink color as the costume is lightly placed at the bottom of the screen.

▲ Add circular lights to the stairs and draw cherry trees onstage. By using the same color as the costume, the composition comes together.

◀▲ Spotlights add to the background. Also, the sky is not just solid blue but is punctuated by clouds.

▶ When processing the illustration, lightly add only colors and patterns so they don't get in the way of the character. Finally, add the audience to complete the background.

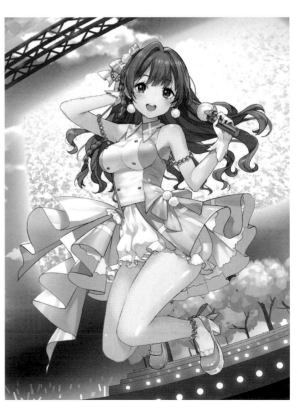

Blend the Character with the Background

Now that you've completed coloring the character and the background, correct the overall color balance so that the illustration coheres. Add ambient light to the background, and don't forget to reflect the light filtering down from above.

1

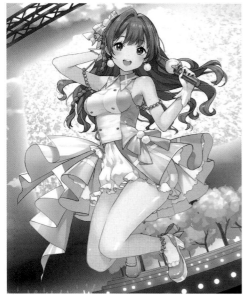

▲ Before correction, the surrounding color wasn't taken into consideration when the character's shading was added. So the character and the background don't look like they're part of the same illustration.

2

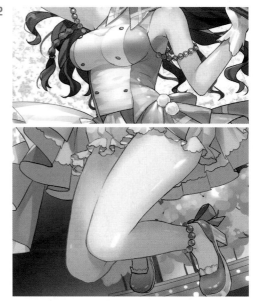

▲ The shadow is darkened by adding a bluish color to the entire shadow surrounding the character. The only exception is the face, which does not need to change.

3

▲ Draw the backlight effects from the monitor on the outline of the whole body, such as hair and clothes, so they emit light as well.

4

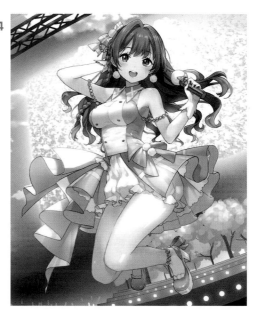

▲ Increase the brightness of the illuminated part of the whole body, including the face, in order to intensify areas other than the outline.

Add Effects to the Illustration

As a final touch, add petals, confetti and spotlights scattered around the character. Create a brilliant stage scene by using colors similar to the costume and accessories.

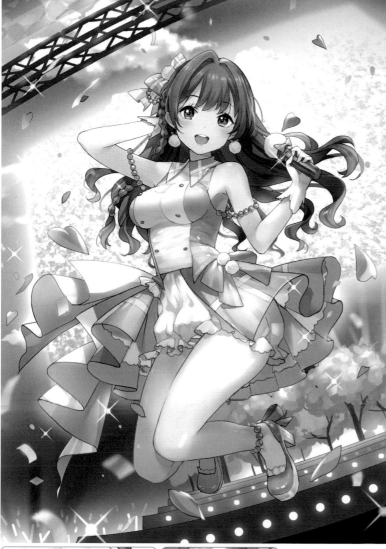

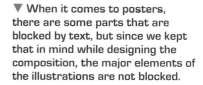

◀ Color in the petals. Glittering rays and confetti are also scattered throughout to add to the atmosphere.

▼ When it comes to posters, there are some parts that are blocked by text, but since we kept that in mind while designing the composition, the major elements of the illustrations are not blocked.

◀ The petals are heart-shaped to match the pop star's aesthetic. Blur the confetti so that it doesn't stand out too much.

▲ A colorful tape was added to the top of the screen to further embellish the scene. A star-shaped effect is also added throughout.

The Dark Tones of Dystopian Romance
Fantasy Illustration for a Graphic Novel Cover

Here the focus is on an illustration for a graphic novel cover. In this tale, dolls and stuffed animals come to life. For the illustration we'll design the expressionless young woman character and the man who is a stuffed animal doctor and be walking you through the production flow and key points involved in drawing a cover illustration.

Illustration by **Nozaki Tsubata**

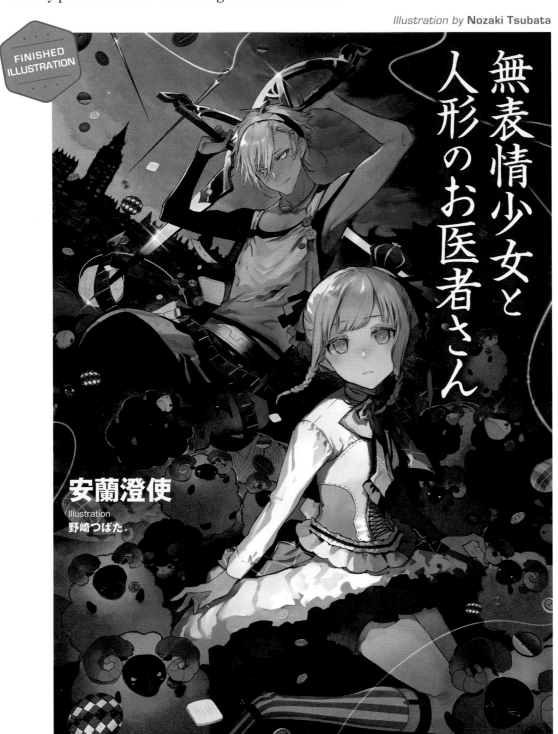

FINISHED ILLUSTRATION

無表情少女と人形のお医者さん

安蘭澄使

Illustration
野崎つばた

PRODUCTION POINTS

① Leave space for text on the cover such as the title.

② Align the character's line of sight with the viewer's.

③ Gradually work on the details while looking at the whole until you reach the final version.

CHARACTER

A doll-like woman and a mysterious doctor

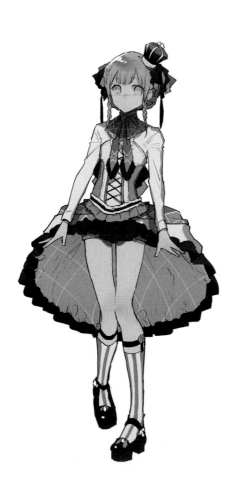

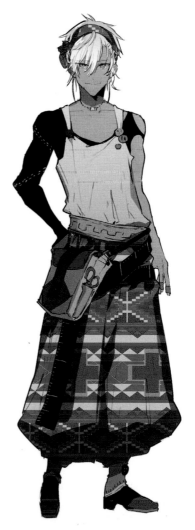

Creating Commissioned Characters

If you're working with a graphic novel as the original text, read the entire work in order to understand the characters' narrative arcs and world view. However, in some cases you may just be working with a commission request that provides only the basic information. If so, use that as the basis of your character design, and start on the illustration!

> **CHARACTERS' IMAGES PER COMMISSION**
> - A fantasy world where people use magic
> - Teenage male and female characters
> - Both male and female character have light hair color
> - Include props such as weapons

World view image

A world where dolls and stuffed animals come to life. Basically, living dolls, some evil or monstrous.

 Roar-!

A story about a doll doctor and a doll-like girl.

▲ The setting is developed in association with the character image. It summarizes the fantasy elements and the basic structure of the story.

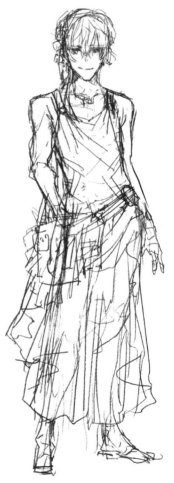

Doll-like woman

- Always with the man
- Usually expressionless
- Doll-like image

▲ A doll-like heroine who contrasts with the world where dolls and stuffed animals come to life. She has an elegant appearance while giving off the image of a captive princess.

Doll doctor

- Tall, lean and lanky
- About 6 feet (180 cm) tall
- Flowing clothing
- More of a tailor than a doctor

▲ The main character of the story is a doll doctor who is a professional peculiar to this world. His outfit doesn't suggest a doctor's, decorated instead with sewing elements.

Thinking About the Two Characters' Relationship

Now that you've completed the character profiles, think about their relationship. How did they meet and what is the nature of their interactions? These are details that will ultimately lift the level of your artistry and the specificity and cohesion of the illustrations you produce.

The young woman was originally captured by an evil teddy bear

The young hero sets off to vanquish the evil bear.

There he met the young woman. Once she regained consciousness, he offered her some candy.

The moment the two met

This set of illustrations summarizes their backstory: he rescues her from the clutches of an evil teddy bear. Organizing the relationship between the two is an effective way to enrich the characters. Try drawing whatever comes to mind.

CHARA'S PROCESS 03 From a Rough Design to a Full-Body Design

Using the rough sketches created earlier, create a detailed full-body design. Pay attention to the balance of the characters' proportions and make any fixes to areas that seem odd or off-kilter.

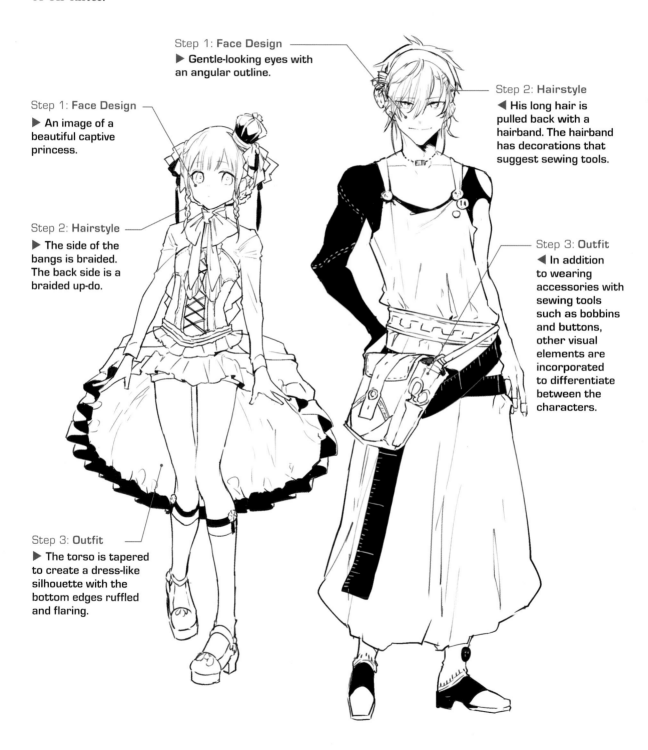

Step 1: Face Design
▶ Gentle-looking eyes with an angular outline.

Step 2: Hairstyle
◀ His long hair is pulled back with a hairband. The hairband has decorations that suggest sewing tools.

Step 1: Face Design
▶ An image of a beautiful captive princess.

Step 2: Hairstyle
▶ The side of the bangs is braided. The back side is a braided up-do.

Step 3: Outfit
◀ In addition to wearing accessories with sewing tools such as bobbins and buttons, other visual elements are incorporated to differentiate between the characters.

Step 3: Outfit
▶ The torso is tapered to create a dress-like silhouette with the bottom edges ruffled and flaring.

Develop the Young Woman's Character

Now you'll be finalizing the young female character. Not only coloring the line art, but preparing a rear-view version as well. The point is to keep her design cohesive by narrowing down the colors used in her color scheme: white, red, blue and yellow.

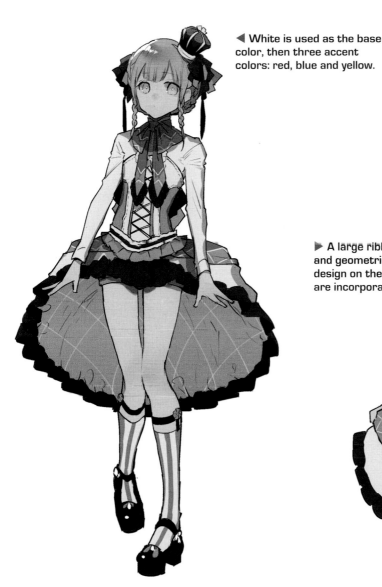

◀ White is used as the base color, then three accent colors: red, blue and yellow.

▼ The crown-like hair ornament is red, yellow, black and white, and the ribbon-shaped hair ornament is red-blue-black, which suits her bright hair color.

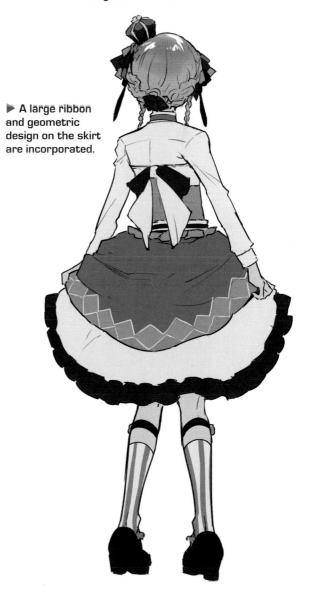

▶ A large ribbon and geometric design on the skirt are incorporated.

▲ She wears a high-low skirt, which is a skirt with different lengths on the front and back.

Develop the Young Man's Character

Now you'll do the same for the second character, adding the pattern to his headband and parachute pants. The color scheme is purple-based, adding in yellow and gray. Don't forget the bright buttons on his chest.

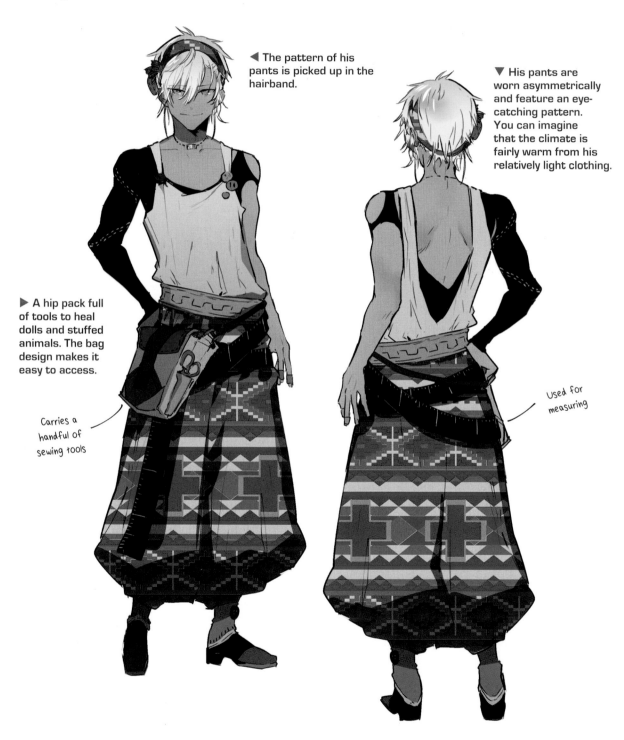

◀ The pattern of his pants is picked up in the hairband.

▼ His pants are worn asymmetrically and feature an eye-catching pattern. You can imagine that the climate is fairly warm from his relatively light clothing.

▶ A hip pack full of tools to heal dolls and stuffed animals. The bag design makes it easy to access.

Carries a handful of sewing tools

Used for measuring

CHARA'S PROCESS 06 Expand the Characters with Expression Charts

Now that you've completed each character's full-body front- and rear-view design, create an expression chart for them. Draw the slight changes in expression of the blank-faced character, in contrast to the dramatic changes in expression of the other.

▶ For the blank-faced character, you can show her expressions with the slight movement of the eyebrows and mouth, and the colors of her cheeks.

▶▼ There are many types of human emotions. When you're limited as to how many you can draw, choose emotions that suit the character and ones where you can show a range of different expressions.

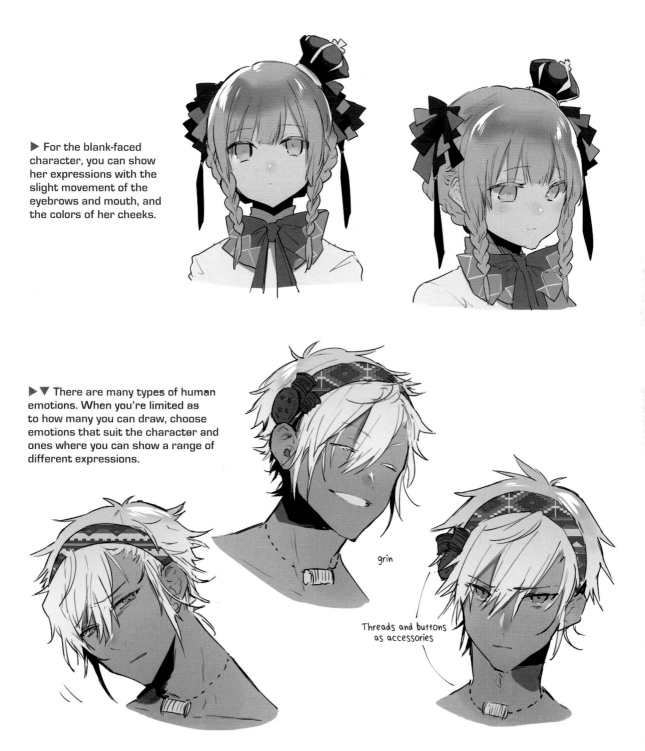

grin

Threads and buttons as accessories

Accessories Express and Suggest Personality Traits

You can get a sense of the characters' personalities by what they carry in their bags. Since this bag is for a tailor, he carries sewing tools and, surprisingly, a scissors-shaped sword.

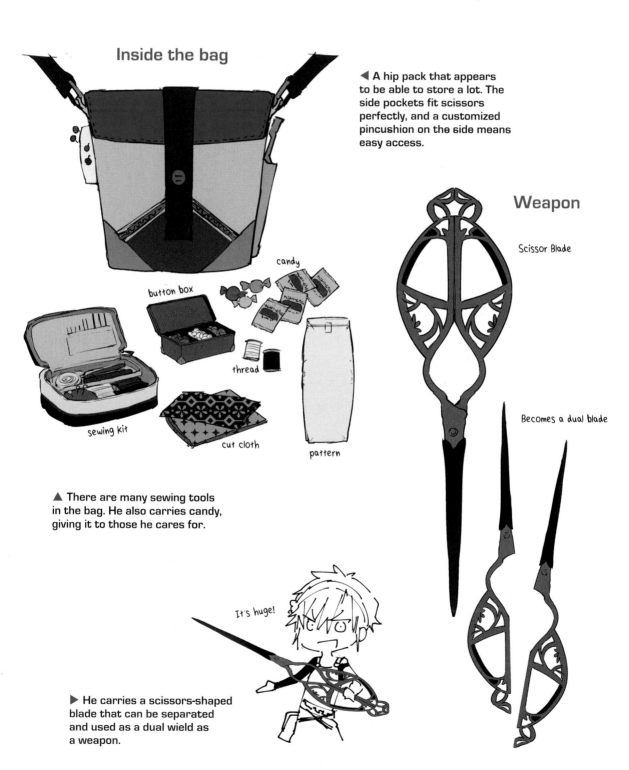

Inside the bag

◀ A hip pack that appears to be able to store a lot. The side pockets fit scissors perfectly, and a customized pincushion on the side means easy access.

Weapon

Scissor Blade

candy

button box

thread

pattern

sewing kit

cut cloth

Becomes a dual blade

▲ There are many sewing tools in the bag. He also carries candy, giving it to those he cares for.

It's huge!

▶ He carries a scissors-shaped blade that can be separated and used as a dual wield as a weapon.

From Illustration Image to Final Composition

Think about the composition of the illustration based on the designed characters and the commission specs for the illustration. Since it's a graphic novel cover illustration, it is also important to picture the final product and leave space for the title.

REQUEST DETAILS OF THE ILLUSTRATION
- Make it colorful
- Two characters, a young woman and man

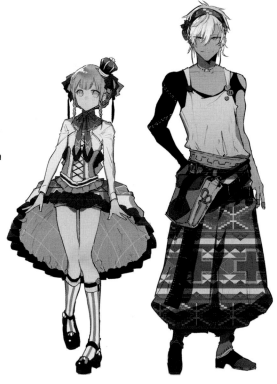

▶ Designed male and female characters. It is a duo of an expressionless young woman and a caring young man who repairs dolls.

About composition

We came up with three different compositional schemes. On the far left, the young man is protecting the woman. In the middle, both of them are in a fighting pose. Then on the right side, the characters assume different poses, giving a sense of unspoken trust. The right side composition feels like it'll be fun to put a lot of elements around them, so we chose it for this project.

From Deciding on the Composition to Creating Line Art

Now apply color to the composition chosen from the previous page. Include details and specific elements at this stage as well. Then create a line-art version of your two characters to check the pose and balance.

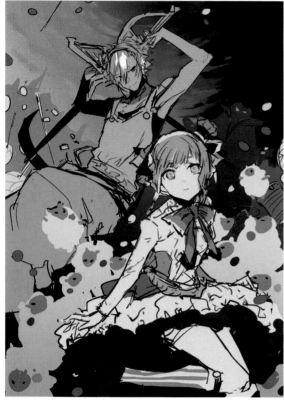

▲ The calm, poised figure in the foreground contrasts with the disturbing atmosphere in the back and gives the illustration a richer, fuller story.

TIPS

Create a composition that can include the title of the work

On a graphic novel cover, it'll contain a variety of content: the title of the work, volume number, author's name and illustrator's and publisher's names. Be sure the title can be placed as large as possible.

▼ When cleaning up the lines, adjustment the line art. The black solid shading of the scissors blade is added at this stage.

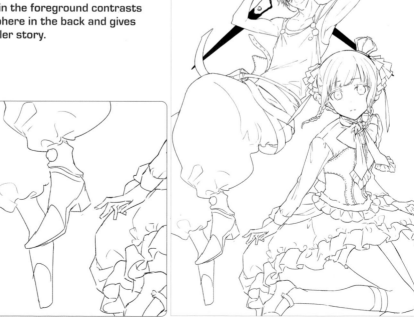

▶ Make sure to still draw parts that are likely to be hidden in the end.

Adjust the Overall Color Balance

Make sure to look at the overall balance while painting your scene. Add patterns to the character's outfit and draw the buildings in the background. At this stage, also adjust the character's position based on the background.

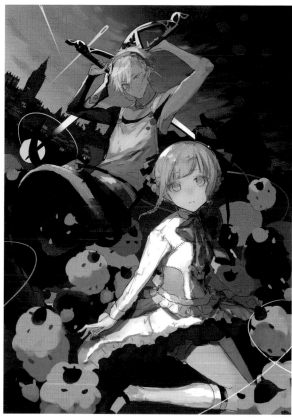

◀ Adjust the position of the background as a silhouette.

▼ Draw the city lights that span the background. Also adjust the position of the young woman.

▲ At this stage, don't paint the details, but focus on the overall balance.

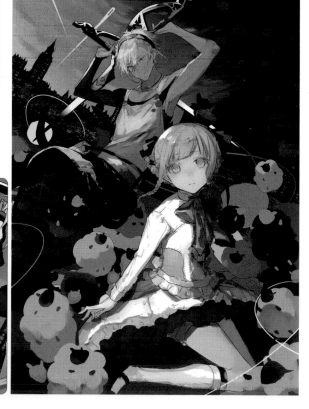

▶ The light of a distant city dimly shines. This is because the farther the object is, the more the light is diffused by the atmosphere.

Pay Attention to Light Source and Color Contrast

As you fix the character's position, draw in the details, and add more color. Make the background a little more blurry in comparison to the characters. Keep in mind that the light source is coming from the left side.

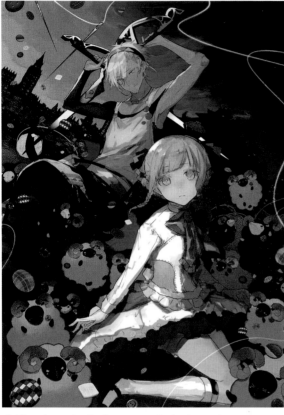

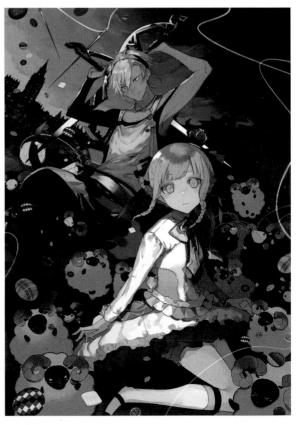

◀ Don't put small items on the character, place them around the characters instead.

▲ The sheep in the foreground, the bear demons on the far right, the buttons, needles and threads are all drawn around the characters.

◀ Add details to their clothes, such as the buttons on his chest.

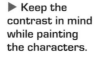

▶ Keep the contrast in mind while painting the characters.

Add Details to the Face and Clothes

Now that you've completed the coloring process, add effects such as gradients or some overlays to bring the illustration together. You can erase the lines you no longer need while touching up the characters' faces.

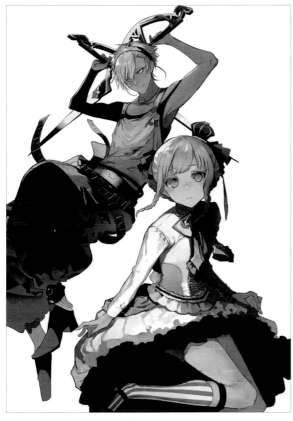

◀ Only the characters are extracted and the lines are adjusted. We erased the lines on the skirt and added patterns and details.

▲ The boundaries between the skirt fabric are blurred, making it look more frilly.

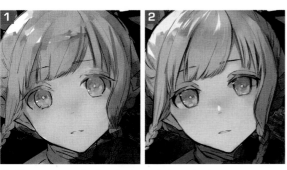

▲ Her eyes at the beginning of the coloring process versus the eyes after the illustration is completed. Not only has their color changed, but the shape of her eyes has changed as well.

▶ The characters' faces, especially their eyes, are the features that make the greatest impact. Even the slightest changes can make a difference, so make adjustments carefully!

Putting the story into a composition

Dynamic Illustration for a Manga Cover

The manga cover becomes the face of the production. Therefore the main characters and the storyline should be apparent to the audience at a glance. Now it's time to learn how to use the character you design to create a composition suitable for a manga cover!

Illustration by **hagi**

FINISHED ILLUSTRATION

狙った獲物は逃がさない。狂気のピカレスクファンタジー

今宵、貴女の宝をいただきます。

新連載!!

第1話「怪盗、参上」

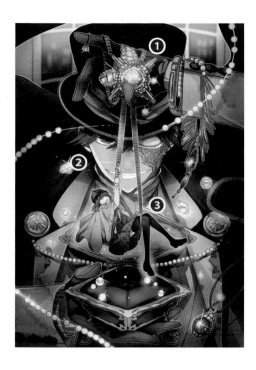

① Using motifs from the manga that will make it easy to understand what the product is about

② Focus on the main characters

③ Create a composition where you can easily understand the characters' relationship

CHARACTER
Young phantom thief and a detective

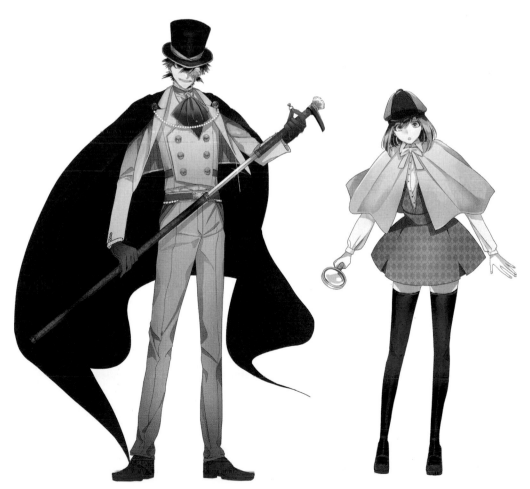

Think About the Main Character's Setting

With manga, the relationship between the characters is what drives the story. The narrative centers on a phantom thief, so think about the type of main character and heroine that would ideally suit this story.

COMMISSION IMAGE

- The main character is a young phantom thief who uses magical powers to collect gems.
- The heroine is a detective investigating the phantom thief
- The main character loves red. He's calm, cool and a little bit unhinged.
- The heroine is a detective high school girl. She seems like the gentle type but she's bold and clever.

▼ The heroine is dressed in an easy-to-understand detective-style costume with a deerstalker and a cape.

▶ The phantom thief is decked out in a three-piece suit, a cloak and a top hat: dapper and dastardly.

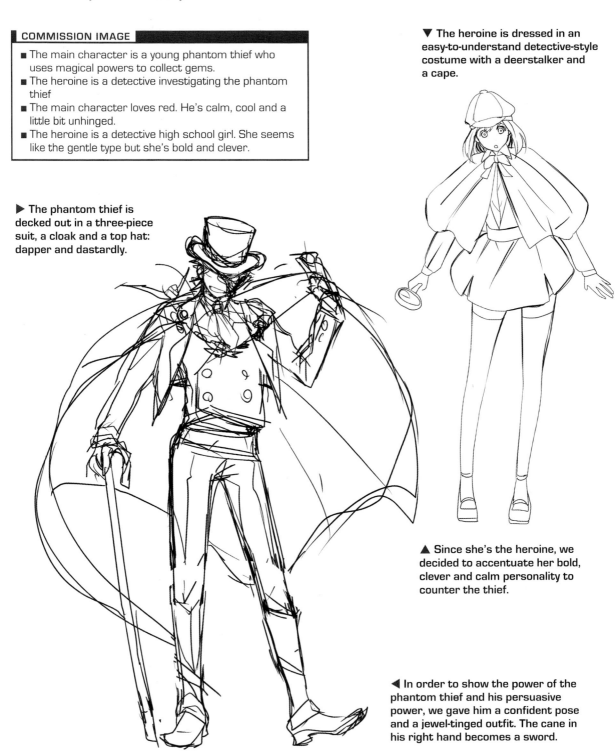

▲ Since she's the heroine, we decided to accentuate her bold, clever and calm personality to counter the thief.

◀ In order to show the power of the phantom thief and his persuasive power, we gave him a confident pose and a jewel-tinged outfit. The cane in his right hand becomes a sword.

CHARA'S PROCESS 02 Use Accessories to Embellish the Main Character

Think about the items and accessories a young phantom thief would possess. If you draw the items as is, they'll have low impact. So instead of thinking about them realistically, imagine the specialized tools that a phantom thief would use.

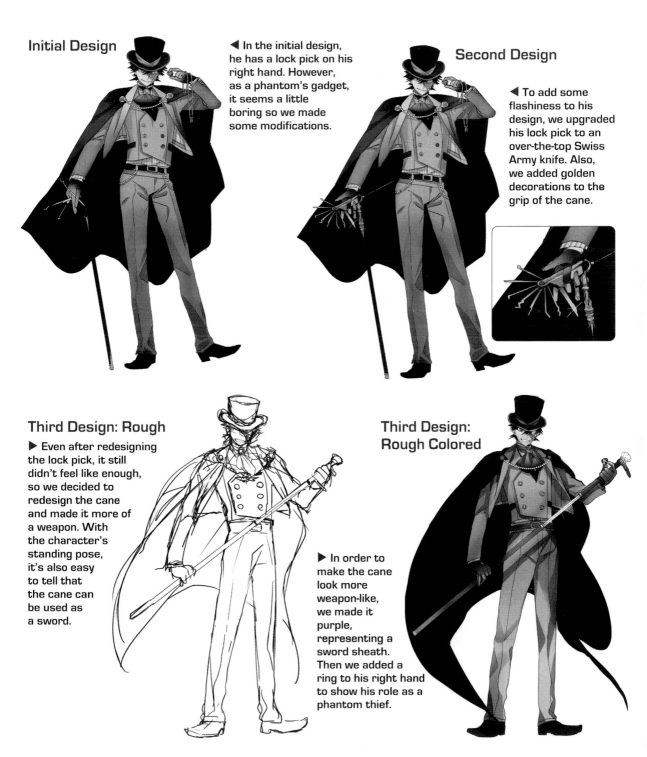

Initial Design

◀ In the initial design, he has a lock pick on his right hand. However, as a phantom's gadget, it seems a little boring so we made some modifications.

Second Design

◀ To add some flashiness to his design, we upgraded his lock pick to an over-the-top Swiss Army knife. Also, we added golden decorations to the grip of the cane.

Third Design: Rough

▶ Even after redesigning the lock pick, it still didn't feel like enough, so we decided to redesign the cane and made it more of a weapon. With the character's standing pose, it's also easy to tell that the cane can be used as a sword.

Third Design: Rough Colored

▶ In order to make the cane look more weapon-like, we made it purple, representing a sword sheath. Then we added a ring to his right hand to show his role as a phantom thief.

CHARA'S PROCESS 03 Complete the Phantom Thief's Standing Pose

Now that you've finalized the character's appearance, think of his color scheme and put it all together in a standing pose sketch. The suit is unified with bright colors, and the top hat and cloak are red. Combining these shades makes this color scheme the main character's personal visual signature.

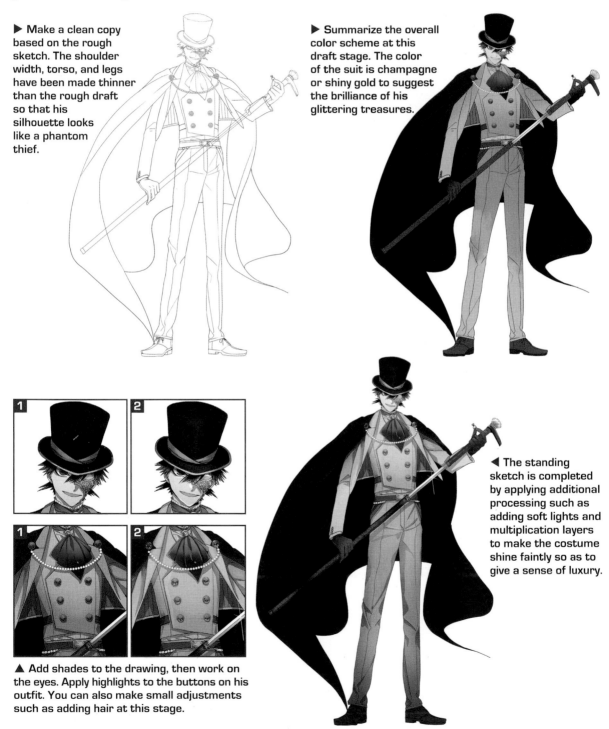

▶ Make a clean copy based on the rough sketch. The shoulder width, torso, and legs have been made thinner than the rough draft so that his silhouette looks like a phantom thief.

▶ Summarize the overall color scheme at this draft stage. The color of the suit is champagne or shiny gold to suggest the brilliance of his glittering treasures.

◀ The standing sketch is completed by applying additional processing such as adding soft lights and multiplication layers to make the costume shine faintly so as to give a sense of luxury.

▲ Add shades to the drawing, then work on the eyes. Apply highlights to the buttons on his outfit. You can also make small adjustments such as adding hair at this stage.

Embellish His Outfit Design and Personality

The trick to designing a character you have in mind is to draw parts and modes of the character that won't appear in the drawing. For example, the back side of the costume, or a range of facial expressions the viewer/reader will never see. This way, the character you have in your head will slowly come together.

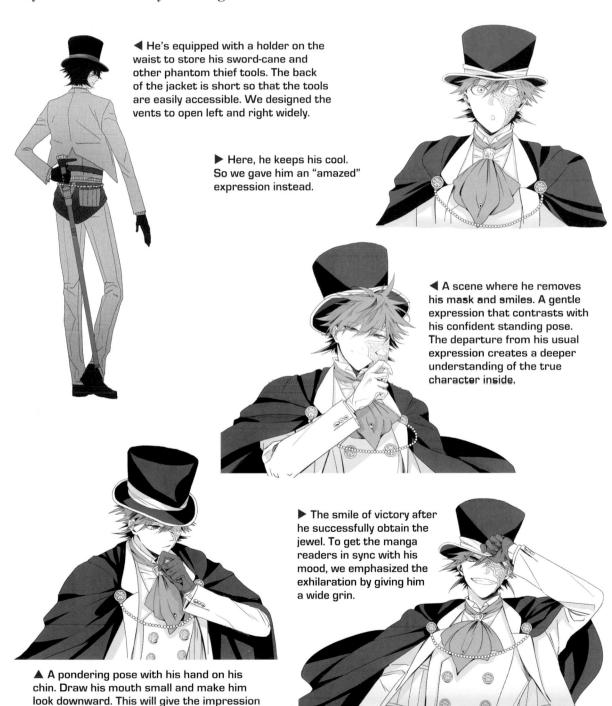

◀ He's equipped with a holder on the waist to store his sword-cane and other phantom thief tools. The back of the jacket is short so that the tools are easily accessible. We designed the vents to open left and right widely.

▶ Here, he keeps his cool. So we gave him an "amazed" expression instead.

◀ A scene where he removes his mask and smiles. A gentle expression that contrasts with his confident standing pose. The departure from his usual expression creates a deeper understanding of the true character inside.

▶ The smile of victory after he successfully obtain the jewel. To get the manga readers in sync with his mood, we emphasized the exhilaration by giving him a wide grin.

▲ A pondering pose with his hand on his chin. Draw his mouth small and make him look downward. This will give the impression that he's thinking deeply about something.

Think About the Heroine's Appearance

Alongside the phantom thief, there's his rival: our main character, a young woman detective. In order to finish the character design, think about how we can color the heroine and her rival.

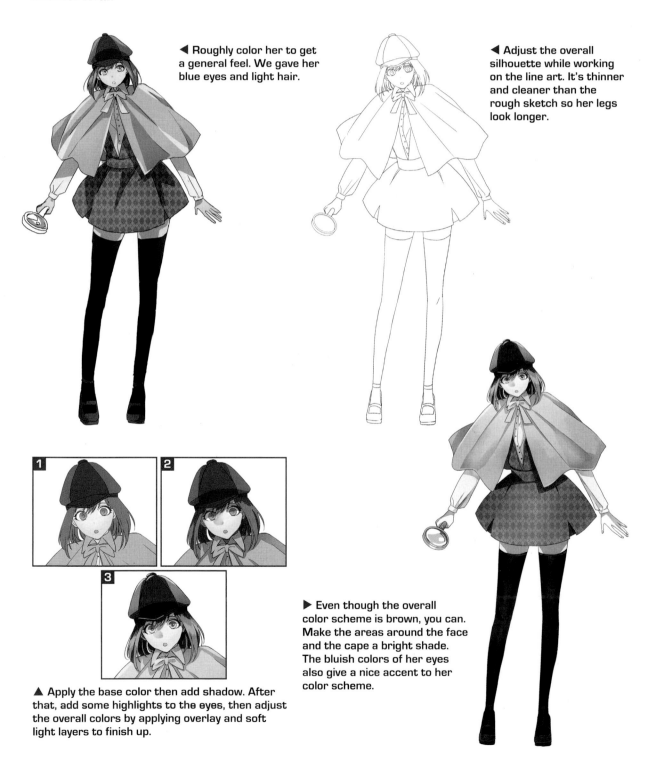

◀ Roughly color her to get a general feel. We gave her blue eyes and light hair.

◀ Adjust the overall silhouette while working on the line art. It's thinner and cleaner than the rough sketch so her legs look longer.

▲ Apply the base color then add shadow. After that, add some highlights to the eyes, then adjust the overall colors by applying overlay and soft light layers to finish up.

▶ Even though the overall color scheme is brown, you can. Make the areas around the face and the cape a bright shade. The bluish colors of her eyes also give a nice accent to her color scheme.

The Heroine's Range of Poses

Just like you did for the young phantom thief, create an expression chart for the young detective to get a better understanding of her personality. Be sure to include her fierce and feisty side as she's the detective that's rivaling the phantom thief.

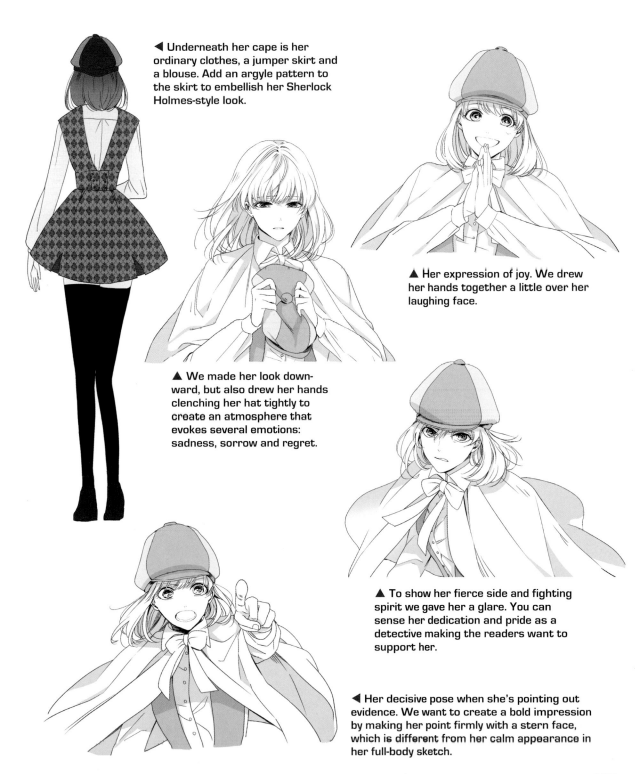

◀ Underneath her cape is her ordinary clothes, a jumper skirt and a blouse. Add an argyle pattern to the skirt to embellish her Sherlock Holmes-style look.

▲ Her expression of joy. We drew her hands together a little over her laughing face.

▲ We made her look downward, but also drew her hands clenching her hat tightly to create an atmosphere that evokes several emotions: sadness, sorrow and regret.

▲ To show her fierce side and fighting spirit we gave her a glare. You can sense her dedication and pride as a detective making the readers want to support her.

◀ Her decisive pose when she's pointing out evidence. We want to create a bold impression by making her point firmly with a stern face, which is different from her calm appearance in her full-body sketch.

CHARA'S PROCESS 07 Thinking About the Relationship Between the Two

By drawing the daily appearance of the main character and the heroine and including scenes from their daily interaction, a new side of the character is revealed. The quality of the characters and the impact of the story can be deepened this way.

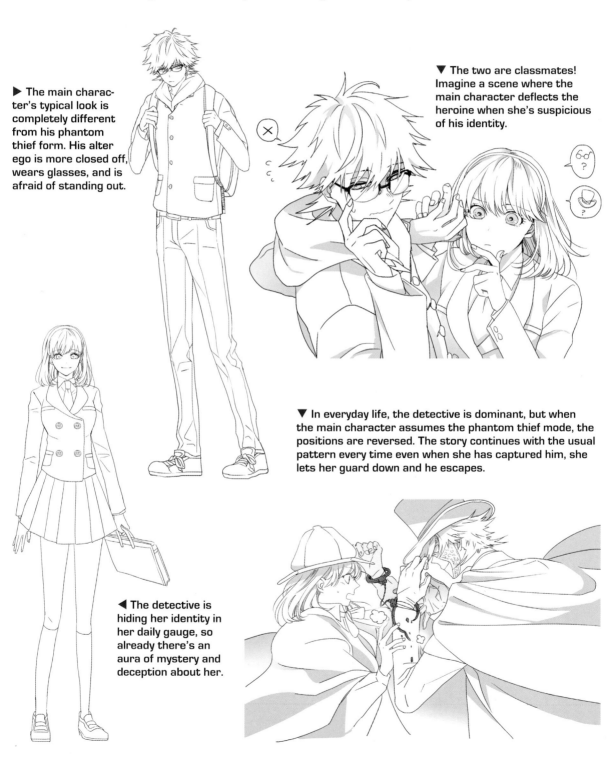

► The main character's typical look is completely different from his phantom thief form. His alter ego is more closed off, wears glasses, and is afraid of standing out.

▼ The two are classmates! Imagine a scene where the main character deflects the heroine when she's suspicious of his identity.

▼ In everyday life, the detective is dominant, but when the main character assumes the phantom thief mode, the positions are reversed. The story continues with the usual pattern every time even when she has captured him, she lets her guard down and he escapes.

◄ The detective is hiding her identity in her daily gauge, so already there's an aura of mystery and deception about her.

MAIN PROCESS 01 Devise a Compositional Scheme

Now that you've completed the character design, dive right into designing the illustration for the manga cover. What kind of composition can we come up with for a phantom thief narrative? By including the elements such as the jewel and the young detective heroine, create a rough sketch of the illustration.

> **ILLUSTRATION THEME**
> - Show the superiority and inferiority relationship of the young phantom thief and the detective girl
> - Make sure the reader can tell who the heroine and the heroine are
> - Create an atmosphere where the phantom thief has lead the heroine around by the nose.

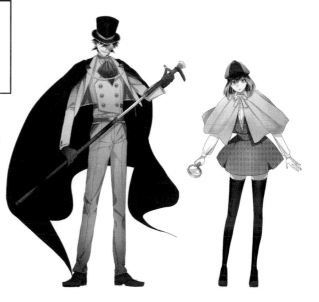

▶ Come up with a composition that will convey the two characters' relationship to the reader. The protagonist, the young phantom thief, has a slight advantage over the detective, so in the composition, we drew them at different sizes to indicate this relationship.

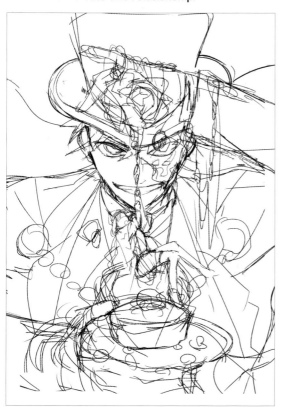

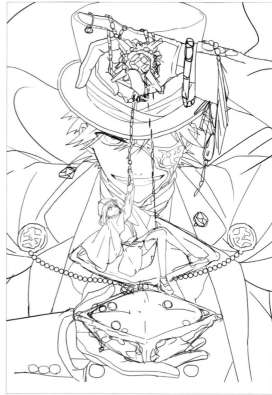

▲ Draw a rough sketch of the phantom thief holding a jewel box and jewels in the center so you can tell that he's the main character and this is his world.

▶ The detective is trying to catch a young phantom thief. She's also the heroine, so she's likened to the key motif, the jewels, and drawn onto the jewel box as an ornament.

MAIN PROCESS 02 Add Colors and Imagine the Final Design

Before starting on the final draft, add colors to the rough draft to get an idea how it's all going to look. By creating a rough color draft before starting a final version, this will ensure a smoother process and a more compelling final result.

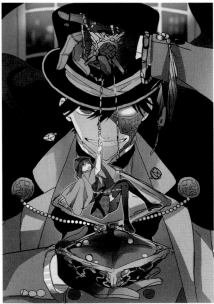

◀ Prime and check the overall color balance. Use different colors for the jewel such as the complementary hues to the character's main accent color.

▶ Check the impression the coloring creates by going through the same process as with the finishing touches, such as adding highlights and applying overlays.

▲ Since there are many elements present, we added white outlines for the phantom thief's fingertips and also to the detective to make sure they don't end up blending in with the background.

▶ In order to add brightness to the whole illustration, we added pearls spanning in an S-curve throughout. Dark colors are layered on the bottom of the screen to make the upper part of the illustration look brighter.

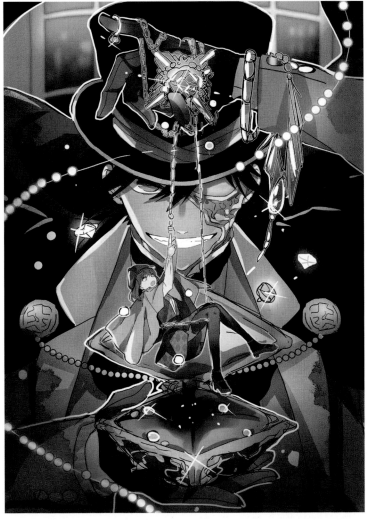

Create Line Art and Think About Where the Colors are Divided

Make use of the characters' energy and create a dynamic rough sketch. Keep the jewel's shape in mind and draw sharp straight lines. Once you've finished the line art, create a color draft using various shades of gray.

◀ Make the metal fitting that's dangling from the jewel thicker than in the rough sketch so that it stands out. Then make the jewelry on his wrist spread throughout the screen to add movement to the composition.

▲ There are many elements the detective is overlapping with, such as the jewel box and the phantom thief himself. So it's easier to work on her on a separate layer.

▶ Once you're done with the line art, use various shades of gray to create a rough color draft. Each shade of gray represents a different color.

◀ After color-coding the line art, you may begin to notice areas, such as the skin and white background, where the colors are similar. If you do gray-scale color-coding first, it'll be easier to find small gaps and unpainted areas.

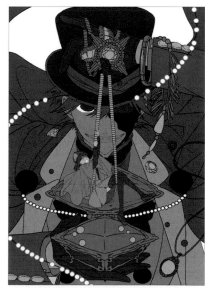

MAIN PROCESS 04 Add Shadows and Highlights

Apply the base color for each character's color scheme, and add shadows and highlights. Include a white outline along the main character, the jewels or any elements that you want to stand out in the illustration.

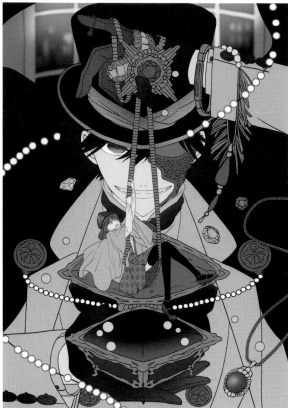

◀ Undercoat the character and jewels while referring to the shades you applied in the colored rough draft. Gradation is used to roughly add shadows to the dark areas on the hats.

▲ Adjust the color of the gloves and add shadows and highlights to the jewels to give them a glossy look.

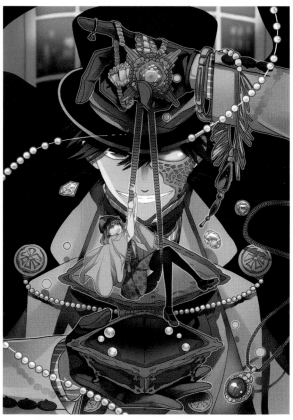

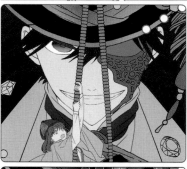

◀ Apply shadows and brightening areas to the primed base. Parts other than the face are painted in a gradation in a similar color to give a soft impression.

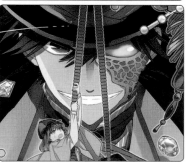

▲ At this stage, shadows cast by objects and highlights that reflect light on brighter objects, such as the jewels and eyes, are added.

Intensify the Colors with Touchups

Once you're done with the illustration, you can add a few touchups such as using a dodge overlay to make the colors more vivid. Keep refining right up until the end!!

1

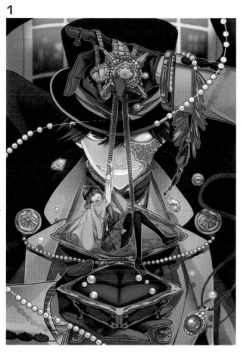

◀ The outfit, jewels and jewelry box have been made brighter overall. At this stage, we're processing the illustration after completing the coloring.

▶ Place a soft light and dodge (linear) layer around the character's face and jewels. Also, darken the left, right, and bottom edges with a multiplication layer to make the center stand out.

2

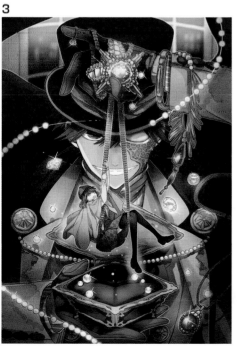

3

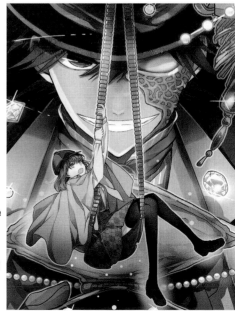

◀ Make the area around the detective glow faintly, adjust the brightness of the center jewel and the overall color with the soft light layer, and finally apply the overlay layer to complete the illustration.

▶ In order to enhance the contrast and add sharpness, the detective's skirt and legs, and the eyes and hair of the phantom thief are darkened with a burn layer.

4

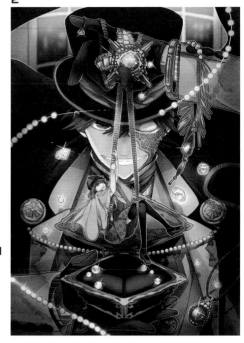

Pop-Style Illustration for Magazine

Illustrations of characters entertain readers in magazines and books as well. In this section, we will explain how to create a character according to the commission request.

Illustration by **Ogino Atsuki**

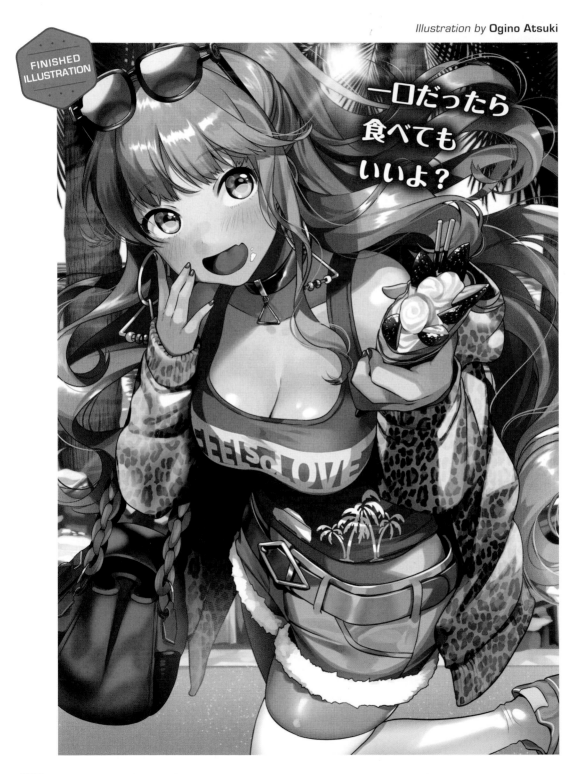

① Appeal to readers through her facial expression and gestures

② Understand the setting and narrative of the illustration at a glance

③ Create a composition that's similar to a manga cover

CHARACTER
A lively big-sister type

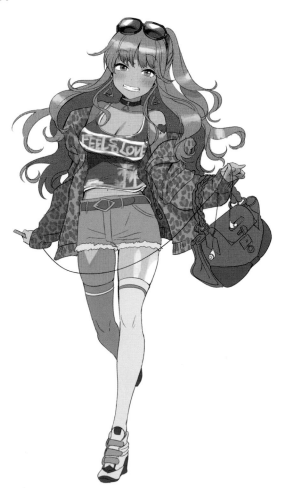

Designing for Different Types

Draw the basic body outline and pose, including the hairstyle, outfit and props that collectively will form the rough design of your character. Create different types of rough designs and expand your ideas.

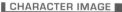

CHARACTER IMAGE

- Girl-next-door character
- She likes flashy items but it's not all that defines her
- Bright, cheerful and optimistic
- Youthful yet with an older-sister vibe

▶ In this sketch, we imagine a more mature version, as if she's in her early twenties: loose and fluffy long hair with a half up do. Accessories such as sunglasses and big earrings and an off-the-shoulder cardigan.

A character rough sketch

Livelier

▶ Here we're drawing a sketch based on a teenaged girl. Give her youthful elements like twin tails and ribbons.

Pile fabric

More mature

▶ In order to create a youthful atmosphere, shorts and bare legs set the right tone.

Inside contents

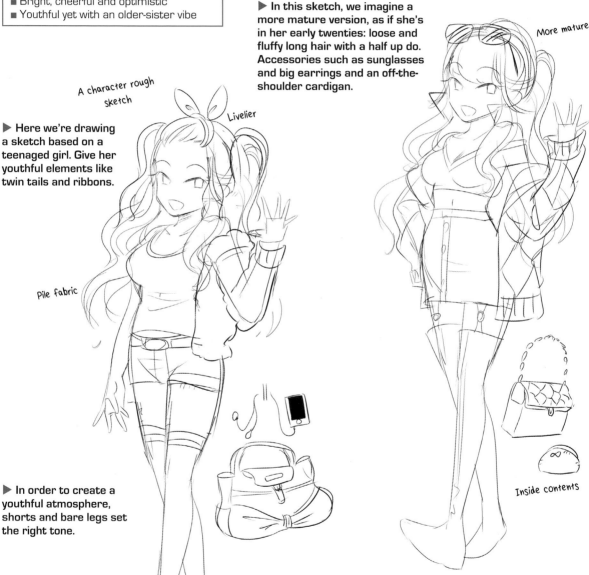

▲ She's wearing a tube miniskirt with garter belts. Inside the bag are items that express a more mature vibe.

Color the Rough Sketch and Decide on Her Final Design

Color the rough designs and think about which direction you want to pursue. While comparing each design and incorporating the client's request, balance out the costumes, hairstyles and accessories and decide on the details of the character.

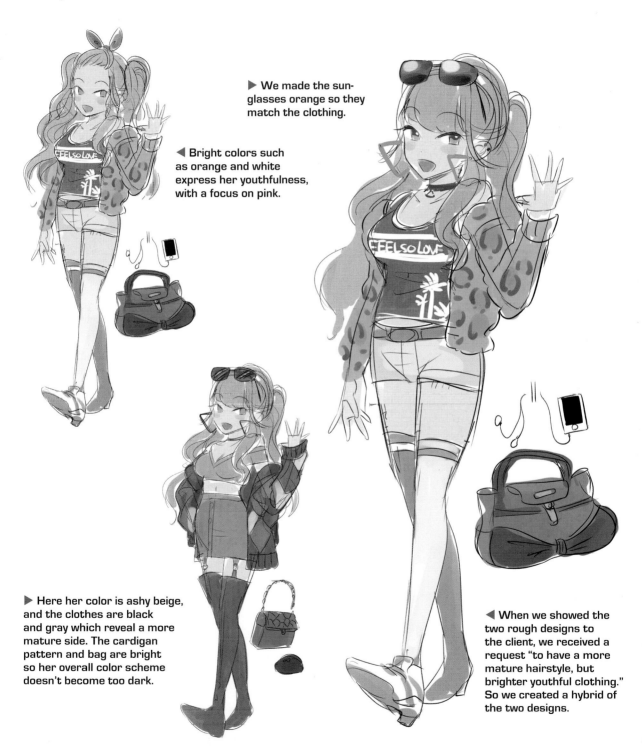

▶ We made the sunglasses orange so they match the clothing.

◀ Bright colors such as orange and white express her youthfulness, with a focus on pink.

▶ Here her color is ashy beige, and the clothes are black and gray which reveal a more mature side. The cardigan pattern and bag are bright so her overall color scheme doesn't become too dark.

◀ When we showed the two rough designs to the client, we received a request "to have a more mature hairstyle, but brighter youthful clothing." So we created a hybrid of the two designs.

115

Using the Rough Sketch to Create the Final Character Design

If you have trouble with the rough design, create a detailed line drawing. While participating in the setting of personality, I will draw facial expressions and poses that often show the image of the character, interweaving small items.

Step 1: **Face, hair clothes**

▶ A joyful expression, hair fluttering out to the sides and her loosely fitting jacket help to suggest her bright, carefree personality.

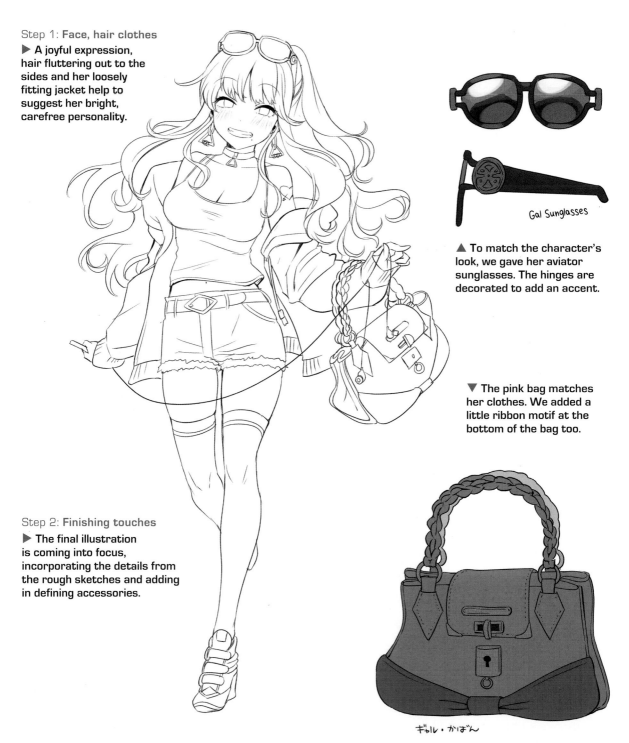

Gal Sunglasses

▲ To match the character's look, we gave her aviator sunglasses. The hinges are decorated to add an accent.

▼ The pink bag matches her clothes. We added a little ribbon motif at the bottom of the bag too.

Step 2: **Finishing touches**

▶ The final illustration is coming into focus, incorporating the details from the rough sketches and adding in defining accessories.

ギャル・かばん

A Range of Moods and Expressions

Color the full-body version and create variations of facial expressions to refine her character. Imagine what kind of mood you want to convey while expanding her range of expression.

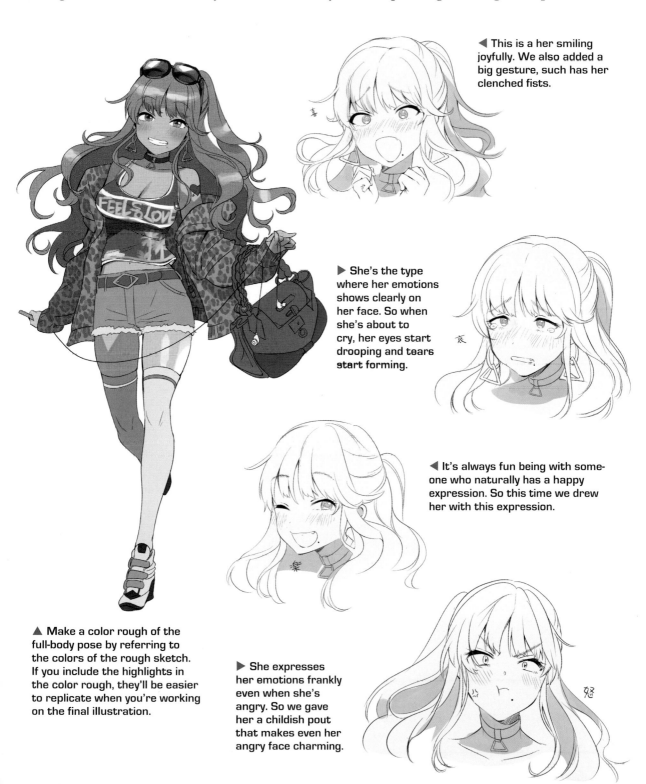

◀ This is a her smiling joyfully. We also added a big gesture, such has her clenched fists.

▶ She's the type where her emotions shows clearly on her face. So when she's about to cry, her eyes start drooping and tears start forming.

◀ It's always fun being with someone who naturally has a happy expression. So this time we drew her with this expression.

▲ Make a color rough of the full-body pose by referring to the colors of the rough sketch. If you include the highlights in the color rough, they'll be easier to replicate when you're working on the final illustration.

▶ She expresses her emotions frankly even when she's angry. So we gave her a childish pout that makes even her angry face charming.

117

Think of a Composition that Suits the Character

For these types of illustrations, it's important to be able to ascertain who the main character is, and what she's doing, from the picture alone. While imagining a detailed setting, highlight the charm and appeal of the leading character.

COMMISSION ORDER
- A pose where she's offering food to the viewer
- Have her appear to be talking to the viewer
- A slice-of-life scene

A bit of backstory?

Scenario: I happened to meet my classmate in a seaside town and we decided to take a walk together. The moment she found the crepe stall, she placed an order. After the food arrived, she turned and offered me a half-eaten crepe.

Relationship backstory: A low-grade friendship where we talk a little but don't know that much about each other.

Outfit: Is she ready for a date, but with somebody else?

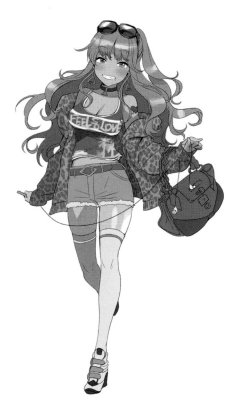

▲ While looking at her full-body pose, think about which of her features appeals to you and what gestures or facial expressions the character is likely to make.

▶ We drew this composition as if it was a frame from a manga, so when you look at it, so capture the overall atmosphere that's conveyed through her pose and facial expression. Also add some easy-to-insert effects.

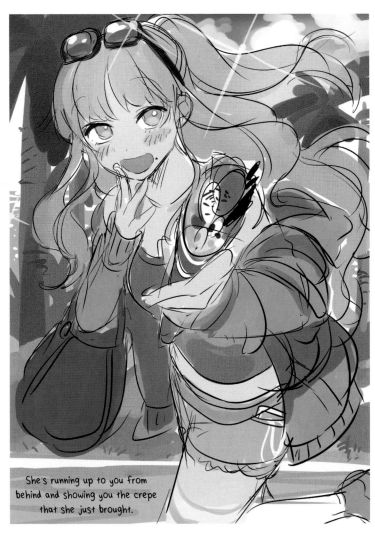

She's running up to you from behind and showing you the crepe that she just brought.

Make Adjustments to the Composition and Finalize the Rough Draft

Show the client the rough sketch of the composition to check if it's in line with the request. Even if there is no specific request for correction, if you find a point that can be improved, you can revise it yourself and enhance the overall quality of the illustration.

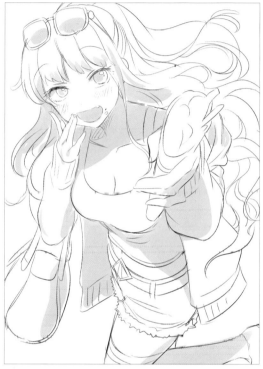

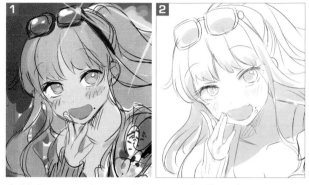

▲ Make corrections to the pose and adjust the angle of her face and hand gesture.

▲ The client who saw the composition rough requested that she lean a little forward so we tilted his upper body a bit.

▶ Not only the character's face and body, but also small items such as the sunglasses, crepe and bag should be drawn in fully.

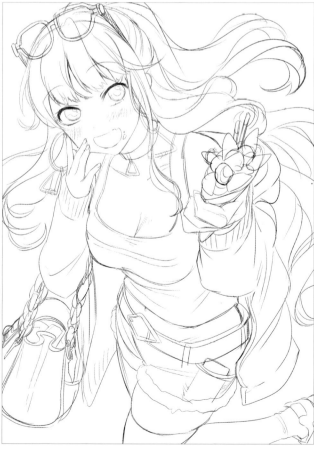

▶ Draft a rough sketch for a clean copy. Since in the rough sketch the body is closer to the front, adjust the hips to lean slightly toward the front so that you could see her right leg.

Finish the Line Art and Color-Code Each Part

Make a clean copy of the draft, generate a line drawing, and color-code each part such as the face, hair, clothes and accessories. Fill in the entire composition so that there will be no unpainted parts later.

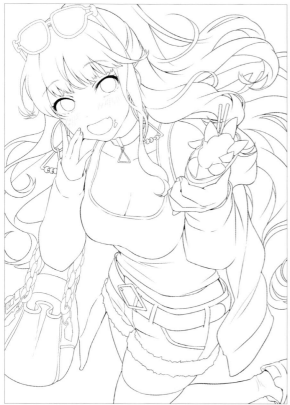

▲ Draw the line art based on the draft. In order to make the coloring process easier, ensure there's no gap in the lines. You could easily use the bucket tool for the color draft.

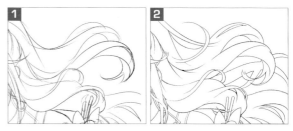

▲ Pay extra attention to the movement and smoothness of the lines making up the hair. At this stage we drew the flow of her hair more clearly than the draft and added volume.

▼ Even with areas of similar color, such as her skin and hair, the tone changes depending on the depth of the hue. The detailed coloring for her eyes, mouth, and the crepe will be completed later. For now, code it with a single color.

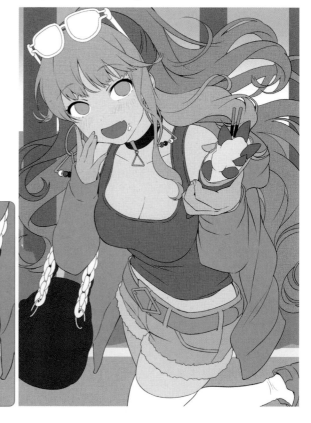

▶ When working on the base colors, it will be easier to color some detailed elements by dividing the layers into smaller pieces.

Finish Up with Lively Color Tones

Taking advantage of the strong sunlight of the seaside setting, the highlights are added to both the character and clothes to enhance the contrast. Paint with healthy, glowing colors overall. The light of the sun is adjusted by adding a highlighting effect.

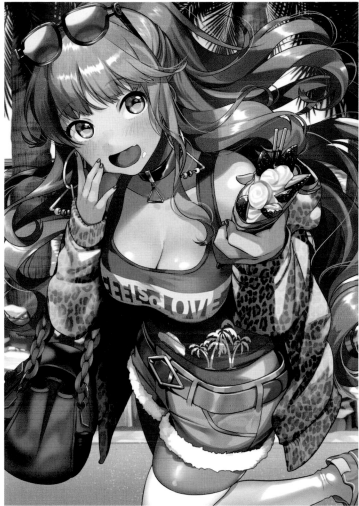

▲ After you've completed the coloring, add some overlay layers to help adjust the skin tone and hair color. Be careful to not make the color tones too bright or too dark.

▼ Finally, add a backlit effect at the top of the screen. By adding such light effects to the illustration, the illustration becomes more sophisticated.

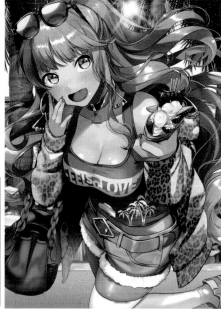

▲ Locate the light source at the top, and add some highlights not only to her hair and skin, but to her jacket and clothing as well. Focus on the visible parts like the road and the trees at the top part of the screen.

▶ The eyes are completed with a bright blue color to give the whole illustration warm tones and a nice cool accent. This will help strengthen the impact and draw viewers to her eyes.

121

Capting the wow factor for a strong first impression
Pinup-Style Illustration for a Magazine Cover

For a magazine cover illustration, we'll design a slender female character dressed in ironic, throwback pinup attire. In this section we will explain how to create a character whose personality can be understood at a glance and how to devise an effective cover illustration.

Illustration by **DS Miles**

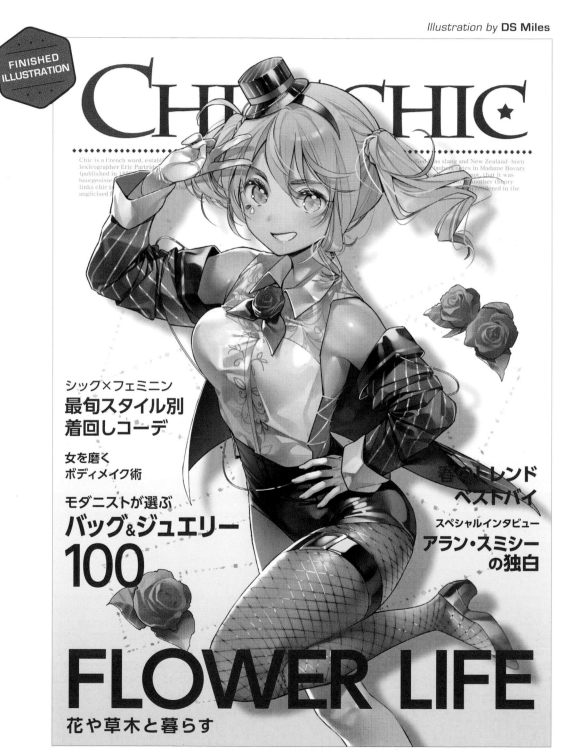

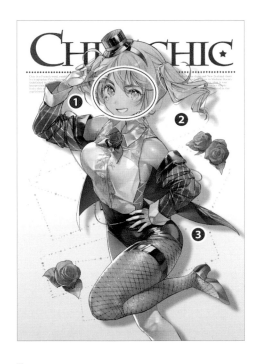

① The first impression of the character is determined by the eyes

② Keep the text and colors in the background in mind

③ Make the character's personality apparent

CHARACTER
A fashionable woman with a botanically themed outfit

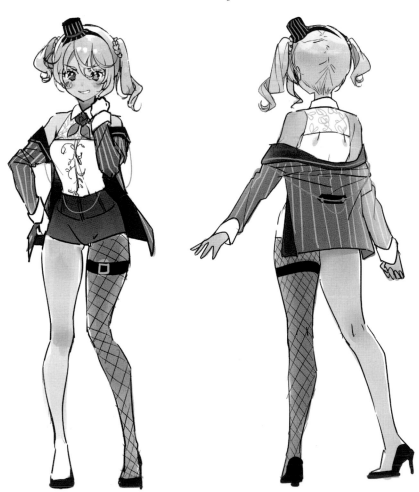

Shifting the Focus to Appearance

Since the order for this character was to focus on her outfit, solidify the design for her clothing. We actively used elements that match her image. It's easy to elevate the initial image of the character by coloring only the parts that are the key elements.

THE CHARACTER'S IMAGE UPON REQUEST

- A young woman in a cheeky modern outfit
- Clothes that fit a slender figure
- Add some botanical designs

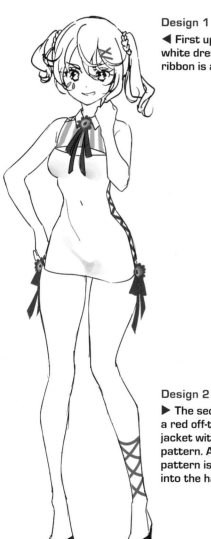

Design 1

◀ First up, a mini-length white dress. The blue-purple ribbon is an accent.

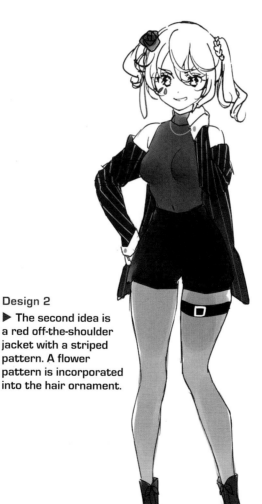

Design 2

▶ The second idea is a red off-the-shoulder jacket with a striped pattern. A flower pattern is incorporated into the hair ornament.

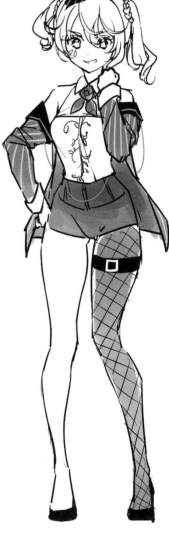

Design 3

▲ Here she wears a sleeveless shirt patterned with vines and leaves and a yellow flower around the neck.

From the Rough to a Full-Body Draft

When the clothing design is decided, not only the front but also the rear-view line drawing are created. The eyes are a major determining factor as to the impression the character makes and the hairstyle attracts attention when distinguishing the character, so draw that with special attention.

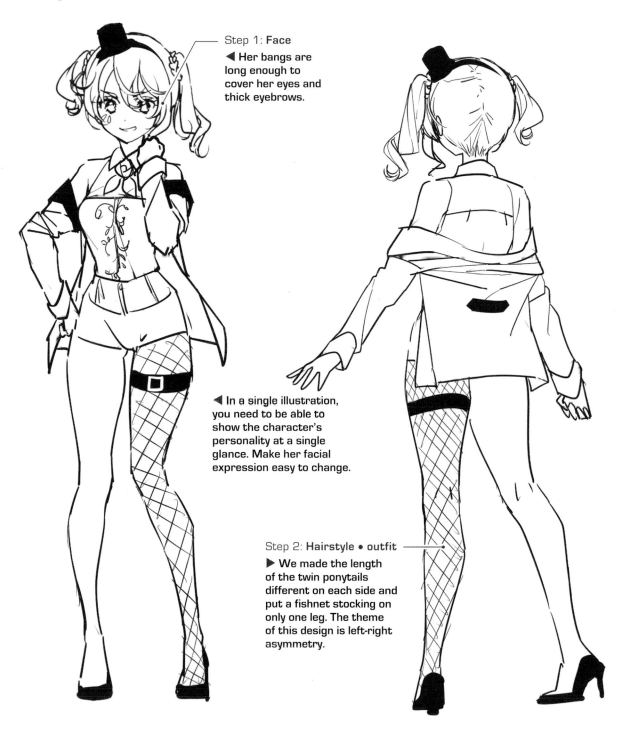

Step 1: **Face**

◀ Her bangs are long enough to cover her eyes and thick eyebrows.

◀ In a single illustration, you need to be able to show the character's personality at a single glance. Make her facial expression easy to change.

Step 2: **Hairstyle • outfit**

▶ We made the length of the twin ponytails different on each side and put a fishnet stocking on only one leg. The theme of this design is left-right asymmetry.

CHARA'S PROCESS 03 Draw Various Facial Expressions

After designing her standing pose, the next step is to create a facial expression reference sheet. By drawing various facial expressions, the character's personality and range of expression will expand. This will be a good reference when you close in on the final illustration.

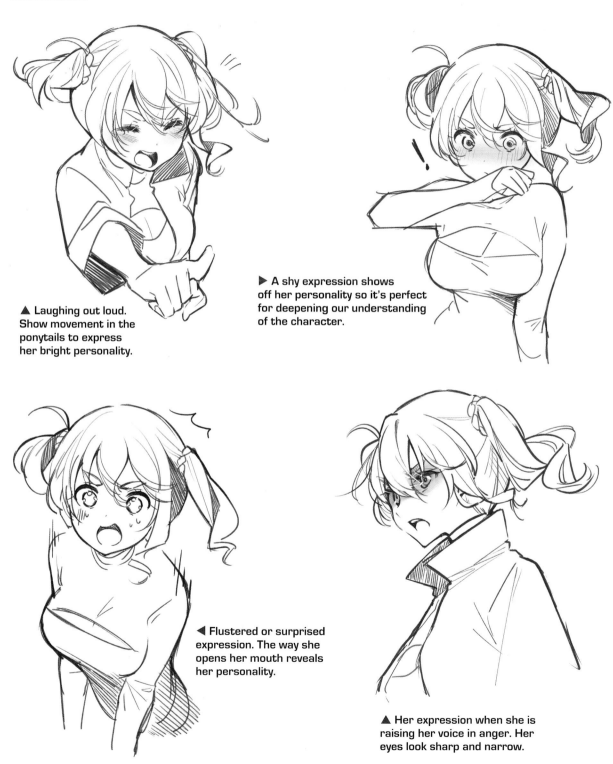

▲ Laughing out loud. Show movement in the ponytails to express her bright personality.

▶ A shy expression shows off her personality so it's perfect for deepening our understanding of the character.

◀ Flustered or surprised expression. The way she opens her mouth reveals her personality.

▲ Her expression when she is raising her voice in anger. Her eyes look sharp and narrow.

Drawing Gestures and Poses That Express the Character's Personality

The character's inner life is revealed not only in facial expressions but also in her poses and gestures. Here are two types of postures: one when standing and the other when sitting. Consider which one suits your character best.

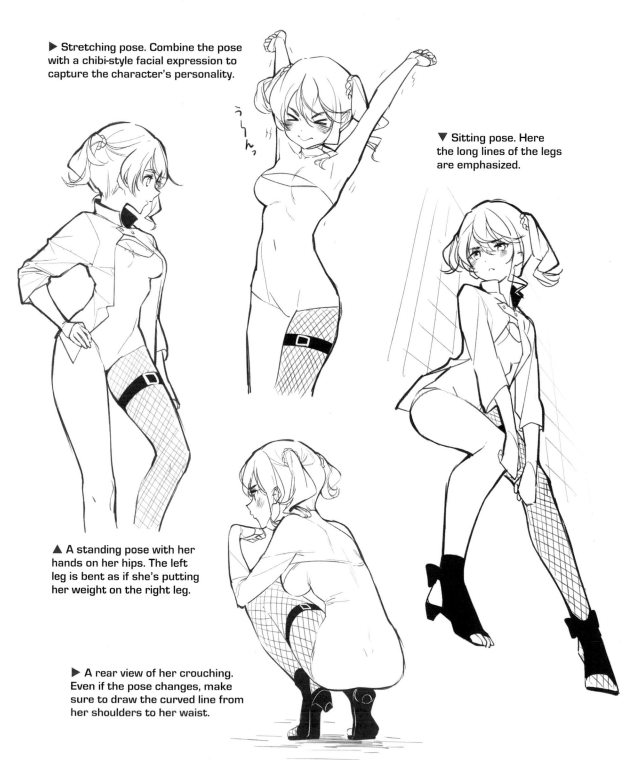

▶ Stretching pose. Combine the pose with a chibi-style facial expression to capture the character's personality.

▼ Sitting pose. Here the long lines of the legs are emphasized.

▲ A standing pose with her hands on her hips. The left leg is bent as if she's putting her weight on the right leg.

▶ A rear view of her crouching. Even if the pose changes, make sure to draw the curved line from her shoulders to her waist.

Designing Her Clothes and Accessories

The next step is to lighten the outline to finish the standing full-body version. The design of her accessories is also finalized. Keep in mind the clothes you designed while deepening your understanding of the character.

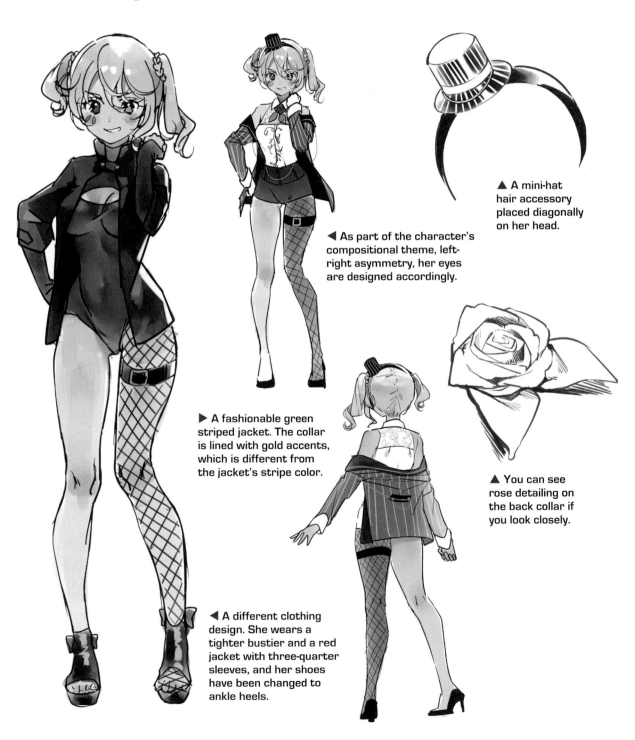

▲ A mini-hat hair accessory placed diagonally on her head.

◀ As part of the character's compositional theme, left-right asymmetry, her eyes are designed accordingly.

▶ A fashionable green striped jacket. The collar is lined with gold accents, which is different from the jacket's stripe color.

▲ You can see rose detailing on the back collar if you look closely.

◀ A different clothing design. She wears a tighter bustier and a red jacket with three-quarter sleeves, and her shoes have been changed to ankle heels.

MAIN PROCESS 01 Devise a Compositional Scheme for the Illustration

The design for the character's appearance and pose is finished. Now it's time to feature her in a magazine cover illustration. Try out a few different compositional concepts until you find the one that's best.

COMMISSION ORDER FOR THE ILLUSTRATION

- Illustration with a vivid flavor
- Use clean and transparent colors.
- Incorporate botanical motifs

▶ This composition captures her posture when she's sitting on the ground looking up at the viewer. It has a calming feel to it.

▲ In this compositional scheme, she's crouching forward. With this, her clothes are a little hidden by the body.

▶ Here is a slightly diagonal view of a pose where she's raising one leg. It gives off a very energetic vibe, so we'll proceed with this one.

Create a Rough Sketch with the Background

Now that you've decided on the composition, draw a rough sketch. Apply color to the character and add a background. There are many plain backgrounds on magazine covers, but not this one!

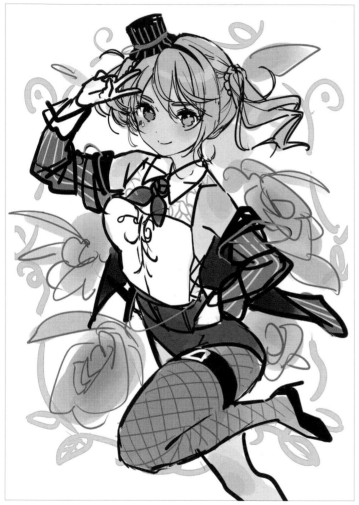

▲ To her pose we added a smile. The background is scattered with the same yellow rose motifs you can see on her neck.

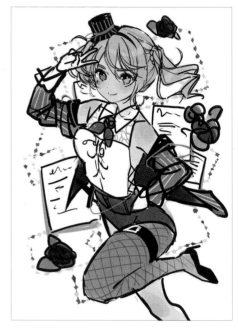

▲ A different background pattern. In this one we add red roses and love letters scattered around.

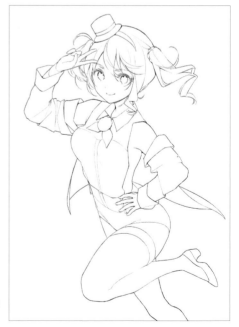

▶ Make a clean line-art version based on the rough sketch.

MAIN PROCESS 03 Color-Coding and Creating a Colored Draft

The line art is brightly color-coded. Add some dark colors and shadows. The wrinkles and unevenness of the garments are expressed by the shadow colors. Add the patterns to the hat and jacket, shirt,and fishnet stocking.

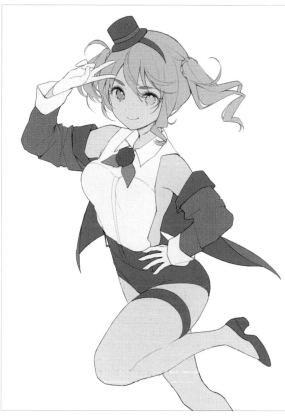

▲ After applying the base color, apply detailed colors around the eyes then her face.

▼ Draw in the rose pattern on her shirt under her collar. Use contouring shades to represent the petals.

▲ Here is line art with base colors. Determine the position of the highlight for her eyes.

▼ Add wrinkles on her clothing throughout the whole body. Then apply gradation to the shadow colors to give it a three-dimensional effect.

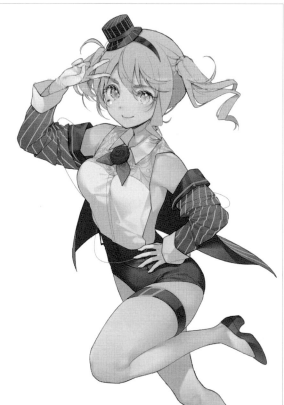

Add Highlights to Refine and Enhance the Illustration

Include more patterns and side straps to add brighter highlights than the base color. By adding highlights, you can enhance the texture of the materials used in her outfits. Adjust also the shape of the legs.

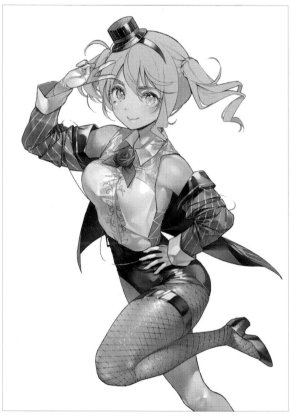

◀ Draw in her fishnet stocking. Add highlights to her hat and jacket for a three-dimensional finish.

▲ The bottom portion is highlighted to bring out its leather texture.

▼ Adjust her eyes, eyebrows and bangs as needed. Add accent lines to the eyes to make them stand out.

▶ The light is coming from the upper-left-hand side, so take that into consideration when shading the illustration. The flow of her hair should also be expressed with shadows and highlights.

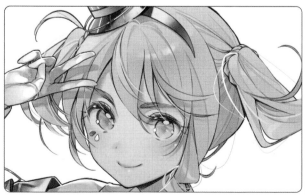

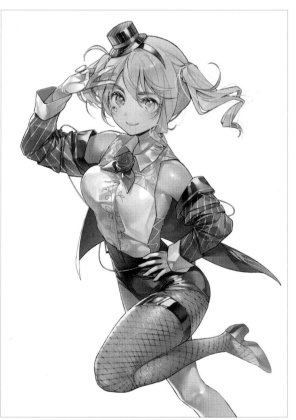

After Completing the Character, Add the Background

The botanical patterns are shown to match the overall atmosphere and design. We changed her expression to a smile. Along with that, the positions of the legs and head are adjusted. With the addition of the rough background, keep in mind the text that will appear on the cover of a magazine.

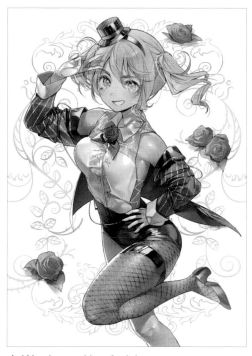

▲ We changed her facial expression to make it suit the pose better. The background here is yellow roses and vines stretched throughout.

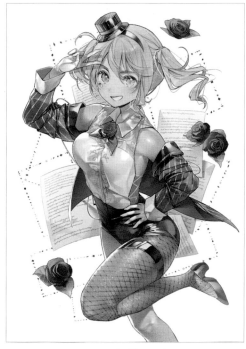

▲ Here, the background is red roses and love letters, suffused by warm colors.

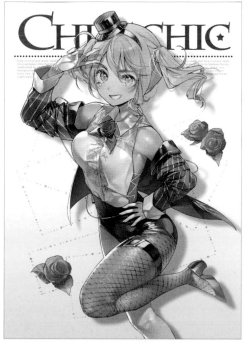

◀ We added the name of the magazine. Then there's a shadow behind the character.

133

Wrap your product in stylish design
Illustration for a Jacket or Other Cover

As a jacket illustration, we dressed the character in a uniform. In this section, we'll design a clerk character with long white hair. Let's take a look at the procedure by which this character and illustration was created.

Illustration by **Yotoi**

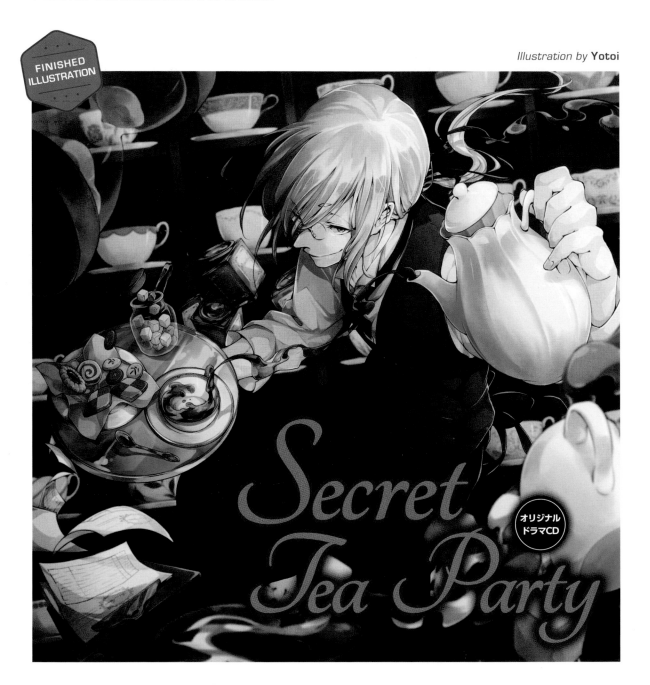

FINISHED ILLUSTRATION

Secret Tea Party

オリジナル ドラマCD

① Use his long hair and apron ribbon to add movement

② Use colors of the same family to create cohesion

③ With the square format, the character's size and position change greatly

CHARACTER
A barista with a mysterious vibe

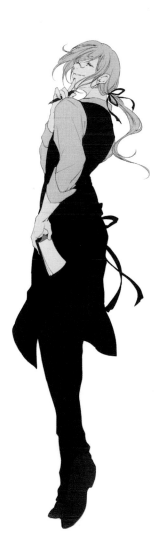

CHARA'S PROCESS 01 From Character Design to Rough Sketches

Based on the requested character specifications, what kind of person springs to mind? How can you embellish and elevate the basic parts of the character such as the clothes, face and hairstyle?

CHARACTER IMAGE COMMISSION ORDER
- Handsome yet quirky
- Barista
- Wears a shirt, vest, apron, or any other coffee shop uniform
- Add accessories to fit the setting
- Age is from late teens to early 20s

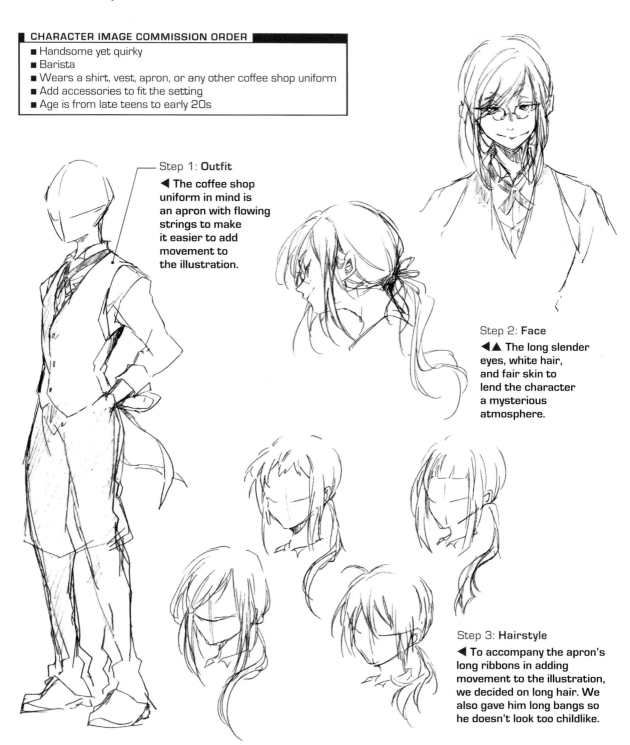

Step 1: **Outfit**
◀ The coffee shop uniform in mind is an apron with flowing strings to make it easier to add movement to the illustration.

Step 2: **Face**
◀▲ The long slender eyes, white hair, and fair skin to lend the character a mysterious atmosphere.

Step 3: **Hairstyle**
◀ To accompany the apron's long ribbons in adding movement to the illustration, we decided on long hair. We also gave him long bangs so he doesn't look too childlike.

From a Rough Sketch to a Full-Body Draft

Now draw a standing full-body sketch and slowly solidify the rough design. You can deepen the character's personality by considering the facial expression patterns along with the front and back view of the character. Also try different poses.

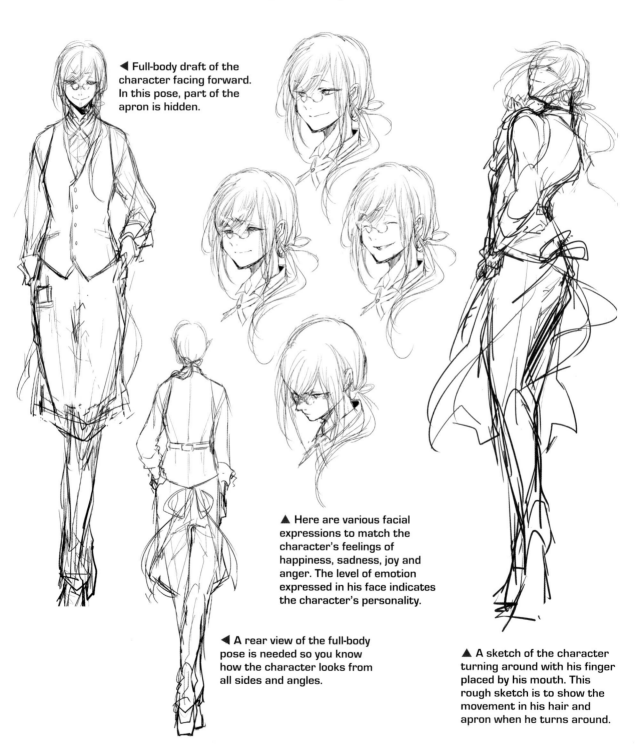

◀ Full-body draft of the character facing forward. In this pose, part of the apron is hidden.

▲ Here are various facial expressions to match the character's feelings of happiness, sadness, joy and anger. The level of emotion expressed in his face indicates the character's personality.

◀ A rear view of the full-body pose is needed so you know how the character looks from all sides and angles.

▲ A sketch of the character turning around with his finger placed by his mouth. This rough sketch is to show the movement in his hair and apron when he turns around.

From Rough Sketch to Line Art

Clean up the rough sketch to create a line-art version. Color will be added at the next stage so make sure to close up the lines. If you're tracing the draft, the lines will not connect, so it's important to ignore the draft lines to a certain degree.

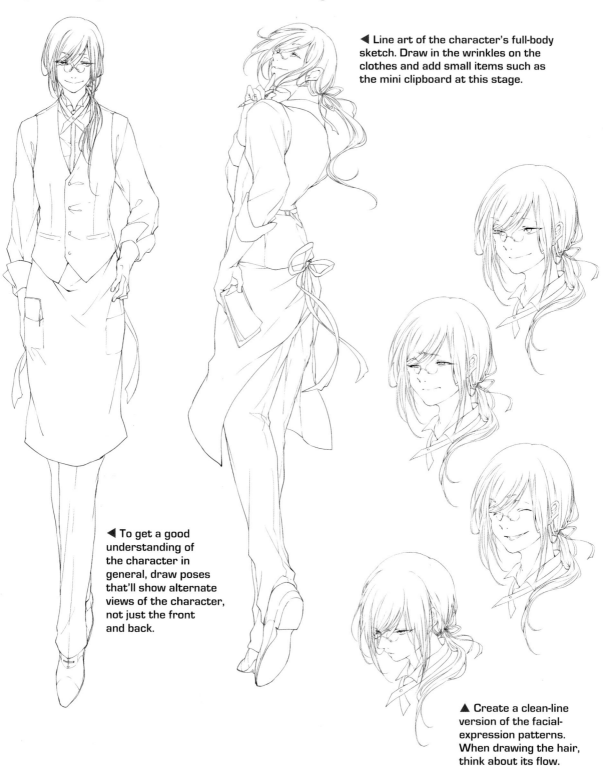

◄ Line art of the character's full-body sketch. Draw in the wrinkles on the clothes and add small items such as the mini clipboard at this stage.

◄ To get a good understanding of the character in general, draw poses that'll show alternate views of the character, not just the front and back.

▲ Create a clean-line version of the facial-expression patterns. When drawing the hair, think about its flow.

Create Multiple Patterns to Solidify the Character's Image

It's also important to create some patterns when painting the line-art versions. Find a color that matches your character's image and look. If you use colors from the same defined scheme or palette, it will look well-balanced.

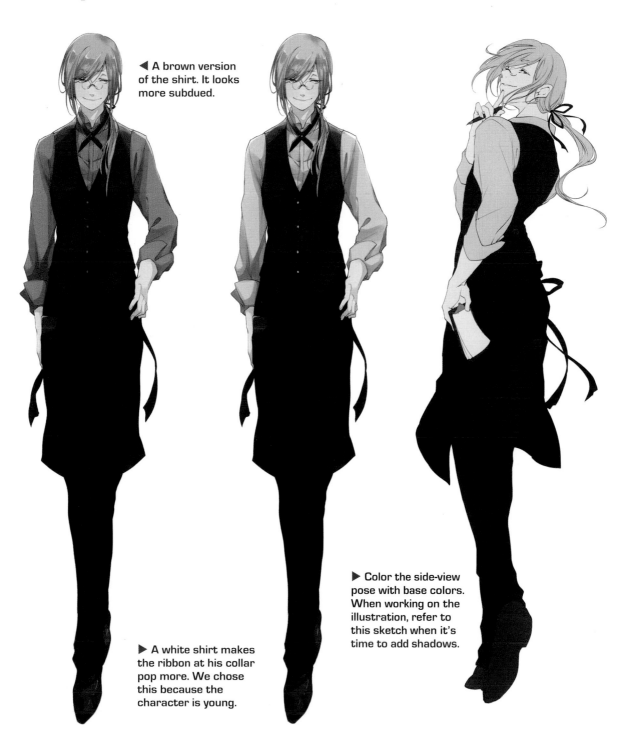

◀ A brown version of the shirt. It looks more subdued.

▶ A white shirt makes the ribbon at his collar pop more. We chose this because the character is young.

▶ Color the side-view pose with base colors. When working on the illustration, refer to this sketch when it's time to add shadows.

Think of a Composition for the Illustration

Now devise a compositional approach that'll showcase the character's personality. Keep in mind the purpose of the illustration and try to incorporate elements to create a composition that will suit the content.

> **ILLUSTRATION CONTENT**
> ■ Cover or jacket illustration
> ■ Pose the character so viewers can easily understand the story and setting

▼ Various compositional schemes for the character. We tried utilizing different views such as low angle, high angle, or making him look from different directions.

◀ On the previous page, we finished this final design of the character. He's a mysterious young man with long white hair and blue eyes.

Think of a Full-Body Pose That Will Suit a Jacket

From the rough drafts made of the general poses, create a composition based on your preferred pose. Add in items that are in the illustration, such as backgrounds and accessories. In addition, the pose and facial expression may change as you get a better understanding of the character's personality.

TIPS

Compositional quandaries

The square format need not be a challenge here. In this case, the point of view is captured from a diagonal high angle instead of a straight angle. This way, all the other objects in the illustration are arranged in a way that will draw movement to the viewers.

◀ A modified version of the composition on page 140 at the bottom right. It is important to lay down various patterns and compare them.

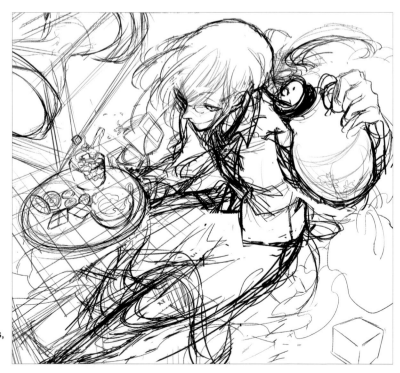

▶ In the rough sketch he swings his right leg. However, we want to give him more graceful movements, so we corrected his pose at this drafting stage.

Complete the Line Art, Then Add the Base Color

While making the best use of the small items added at the drafting stage, make a clean copy without tracing the rough draft. You can work on coloring later, so it's best to generate the draft without thinking about the colors for now.

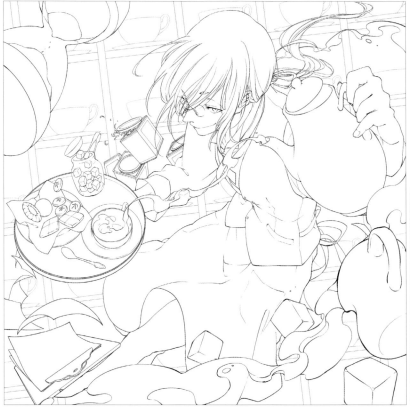

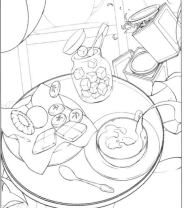

◀ The items used in the coffee shop create a fantastic atmosphere. The background has been changed to a cupboard with tea cups.

▼ Items that could fall and break at any moment. This instability keeps the viewer on edge.

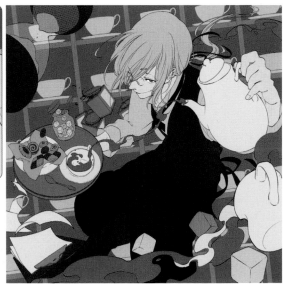

▲ Since the shadows will be added at the next stage, we'll use for bright colors for the base.

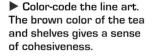

▶ Color-code the line art. The brown color of the tea and shelves gives a sense of cohesiveness.

Apply Shadow Colors to Add Dimension

By adding bright highlights and shadows that are darker than the base color, the illustration will have a three-dimensional effect. Making the boundary of the highlight color a gradation gives the scene a more natural look.

◀ By adding shadows, the texture is significantly different from the base-color version. Be aware that the light is coming from the upper-right-hand corner so layer the shadows accordingly.

▼ Make it brighter by adjusting the final color and adding a stronger shadow color.

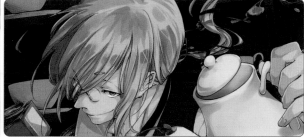

▶ Add patterns to the scrap papers and paper cups, the pot in the character's hand, and the slips in the foreground. Pay close attention to the uneven surfaces of the objects when coloring.

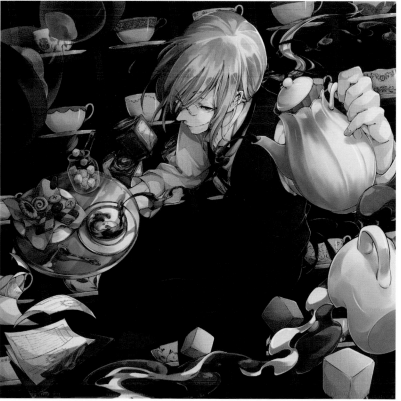

▲ Enhance the texture of the metal tray by adding reflections.

Blur the Background to Add a Realistic Touch

By blurring the sharply drawn-out background, it becomes more natural and easier to take in the whole composition. Adjust the contrast of the entire illustration to make it more vivid.

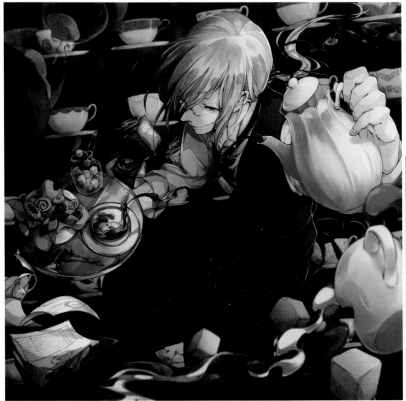

◀ Blue out the elements that are not part of the main character, such as the tea cups in the background and the milk pitcher in the foreground. This will create a more natural feeling of depth.

▼ Another point is to blue out the objects in the back.

▲ Sepia tones give the illustration a warmth.

▶ Keep in mind that the light is coming from the upper-right-hand side. Be sure to make anything on the top right brighter, and bottom side darker overall for a finishing contrasting touch.

Designing Fan Art

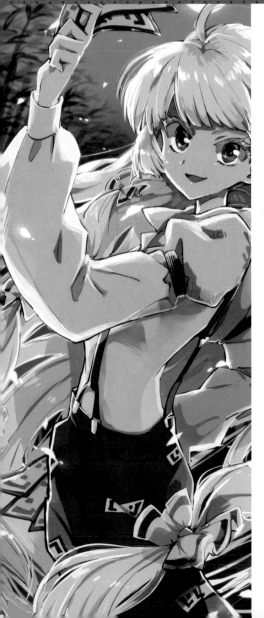

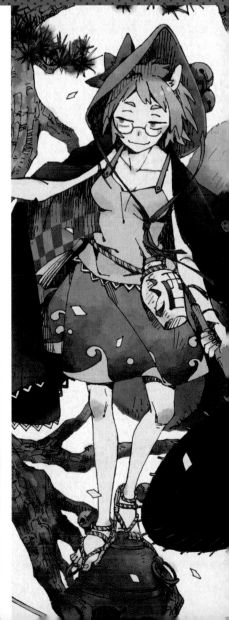

Tributes and transformations
TOUHOU PROJECT: Mamizou Futatsu-Iwa

Paying tribute to a character from an existing work with fan art of your own design is another way to channel your creative pursuits. To start, we're looking at the design and creation of illustrations of Mamizou Futatsu-Iwa, who appears in "Touhou Project."

Illustration by **Asahi**

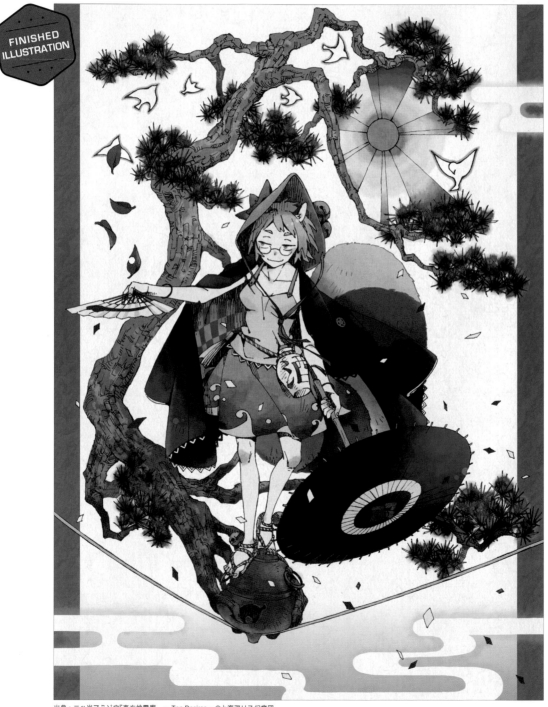

FINISHED ILLUSTRATION

出典：二ッ岩マミゾウ『東方神霊廟　〜 Ten Desires.』©上海アリス幻樂団

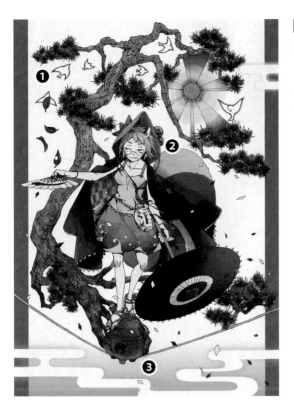

PROCESS POINT

① Match the atmosphere of the setting with the character

② Bring out the character's commanding presence

③ Create an eye-catching composition

The original character

▲ Mamizou Futatsuiwa is an extra boss from the 13th installment of Touhou Project, Ten Desires, (Touhou Shinreibyou). She has a leaf on her head inspired by the Japanese tanuki (raccoon dog) spirit.

Character design used for fan art

▶ A full-body sketch created from the original picture. Aside from the glasses and waistband, the design of the clothes is kept close to the original design.

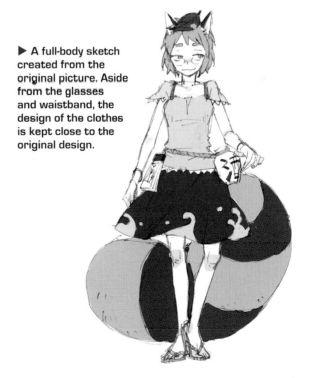

Deciding on the Illustration Composition

Start a draft once the composition of the illustration is decided. Since the process is done using both analog and digital procedures (starting with the next line drawing), the lower persimmon is drawn close to the washbasin.

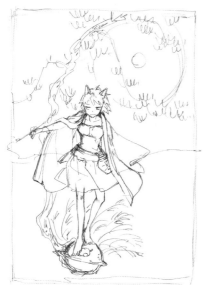

▲ Illustration plan. The composition is strange and interesting, featuring the character in the tea pot and the pine trees.

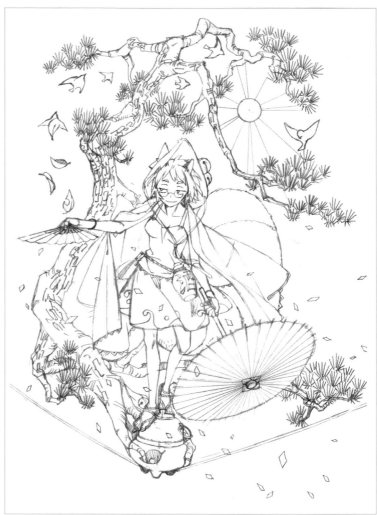

▲ Here the smoke tube was changed to a fan, the umbrella was moved to the other hand and the teapot rests on the string.

▲ Draft while adding what is in the illustration. Scatter the birds, leaves and confetti.

▶ We have adapted different costume elements such as the hat from the first standing picture.

MAIN PROCESS 02 Complete the Line Art and Color Draft

Next you'll create the line-art base from the draft. This process is done digitally. Fill the shadows with lines, and add detail to the background.

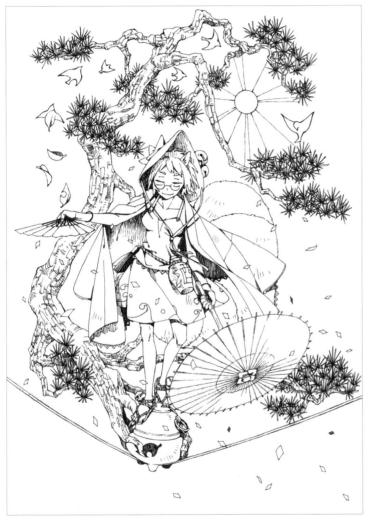

▲ Carefully draw in the detailed elements such as the pine boughs and leaves.

▲ Black solid lines have an analog feel to them by overlapping lines drawn in a single direction.

▶ The characters are faded to give the feeling of age or long use.

▲ The undercoat is the one in front of the illustration. First, paint the illustration with bright colors.

149

Shade in the Main Character and Color the Background

Adjust the color of the character by lowering the saturation, add a pattern to the clothes and paint the background further. The leaves, birds and confetti now come into play. Don't forget to adjust the character's face.

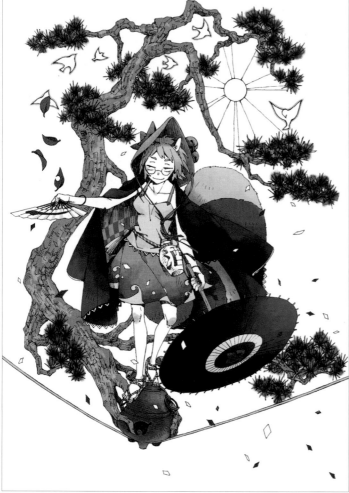

▲ The brown tinged with green suggests a metal pot that has been used for many years.

▼ The line drawing of the bird is painted red when adding sunlight. The pine tree darkens the bottom and adds green to the composition.

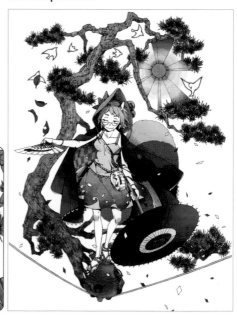

▲ The character has been desaturated and the background colored. The colors and motifs are Japanese style and match the character.

▶ The trunk of the pine is mixed with a light blue color, and the boughs are mixed with a little bright green.

MAIN PROCESS 04 Add Effects and Framing to Complete the Illustration

In addition to adjusting the overall color, you can add a Japanese paper-like texture to the background, place clouds like Japanese paintings, and add frames on the left and right to make it look like a hanging scroll. Finally, adjust the contrast to complete the effects.

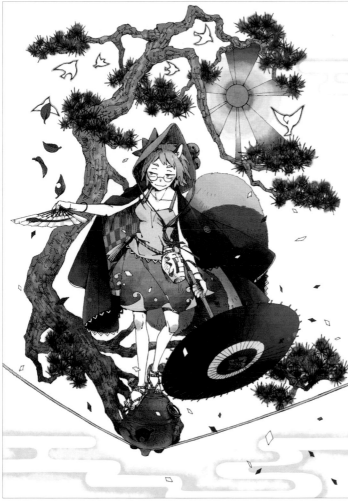

▲ The color of the cape is darkened, and at the same time, a bright color is added to the border.

▼ Frames are added to the left and right, and a dark haze is placed in the clouds below. The overall contrast is also adjusted a little.

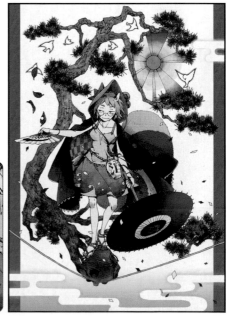

▲ In addition to placing clouds, we are changing colors with the light source in mind, while adding highlights.

▶ The character and background are placed in front of the left and right frames.

Matching mood, setting and atmosphere
TOUHOU PROJECT: Fujiwara no Mokou

Now we'll look at how to create fan-art illustrations using Fujiwara no Mokou of "Touhou Project." An eerie atmosphere is conjured with a moody palette to match.

Illustration by **Shinoasa**

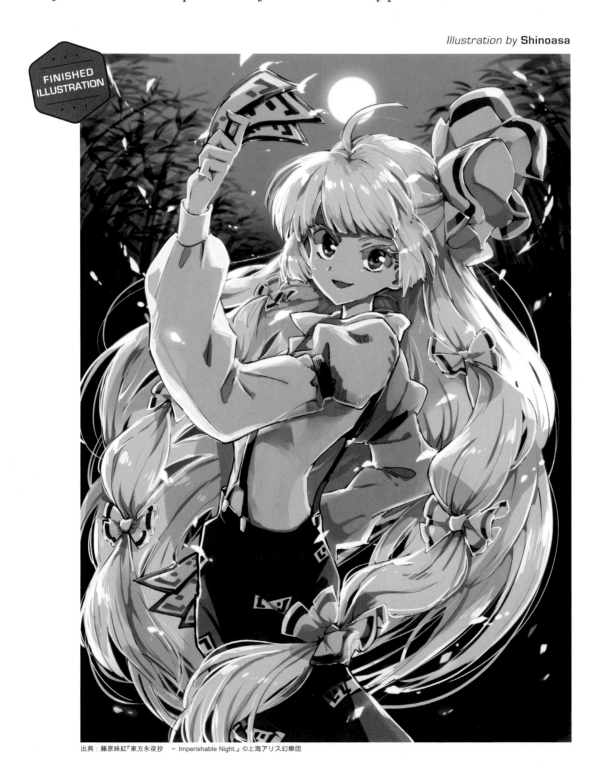

出典：藤原妹紅『東方永夜抄　～ Imperishable Night.』©上海アリス幻樂団

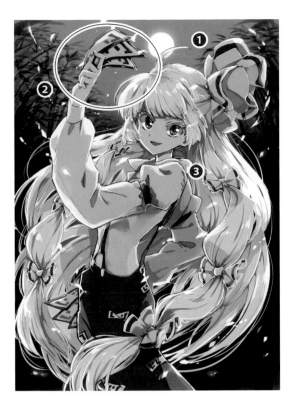

PROCESS POINT

① Match the atmosphere of the setting to the character

② Accentuate the flame elements

③ Not just cute but also cool

The Original Character

▲ Fujiwara no Mokou is an extra boss character from the 8th installment of "Touhou Project": Imperishable Night. She's characterized by her long hair and suspenders.

Character design used for fan art

▶ A full-body sketch created for the illustration from her bow to her lace-up boots.

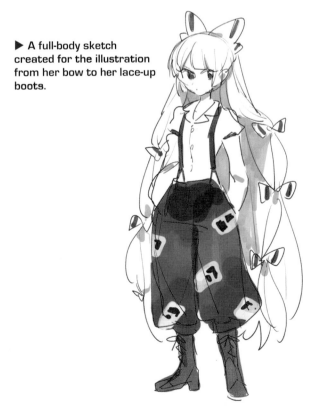

Align and Prime the Line

Now on to the line-art process. At this stage, keep her expression the same while working on the ribbon pattern and other details. We will also be color-coding the sketch in this step.

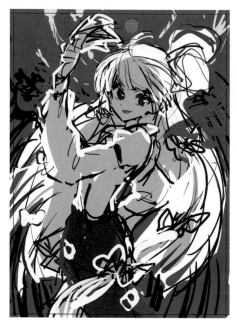

▲ The illustration gives a slightly menacing impression. She's attacking with a smile while being illuminated by the full moon.

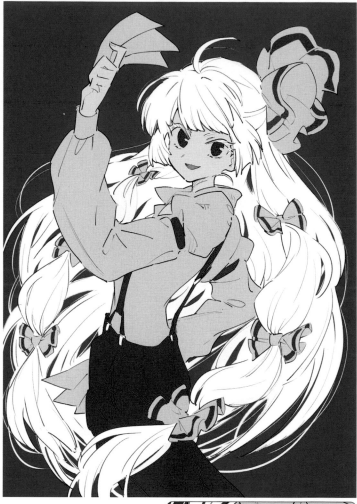

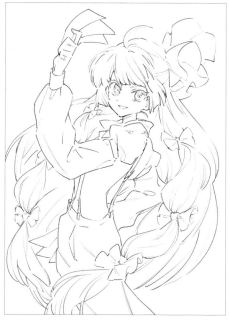

▲ Add wrinkles to the clothes and flow to the hair at the line-drawing stage.

▲ The background is blue because the hair is white. Determine the gap between the hair and the main body at the line-art stage.

▶ Try to keep the long hair cohesive without spreading it too much.

Add Color to Match the Situation

With the full moon in the background, shadows are cast and light flits across surfaces. Highlights are placed based on the moonlight's illumination. Add sharpness to the character's colors at this stage as well.

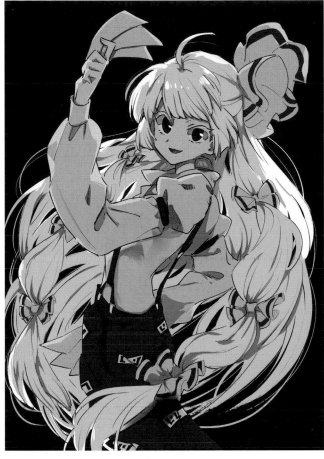

◀ After drawing the pants pattern, add in shadows.

◀ The background is darkened to fit the situation. It can be brightened later.

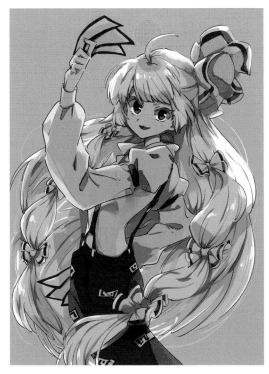

◀ Note that red has been added to the shadow color.

▶ The moon adds highlights. The shadow color is also increased accordingly.

Change the Color of the Line and Add the Background

Change the color of the main lines where the moonlight hits. Light hits an object and is reflected and diffused, making the outline appear blurry. Also add a background to match the perspective and capture the character.

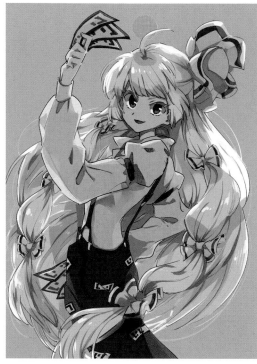

◀ Change the color of the main line while at the same time drawing a pattern.

▲ Change the line color to red or orange instead of black. The central part of the body, which is not exposed to much moonlight, has a color closer to black.

▼ The background suggests a bamboo grove where her sister Beni lives.

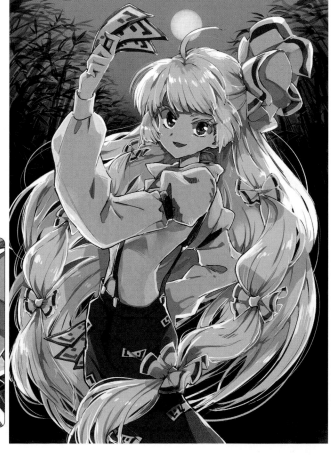

▲ Draw bangs and increase the highlighting.

MAIN PROCESS 04 Arrange the Final Illustration with Effects

Add effects such as flames around her body and make color adjustments such as increasing the contrast in the overall illustration. In order to intensify the glare caused by the full moon, increase the highlights caused by the moonlight and add more blue tones.

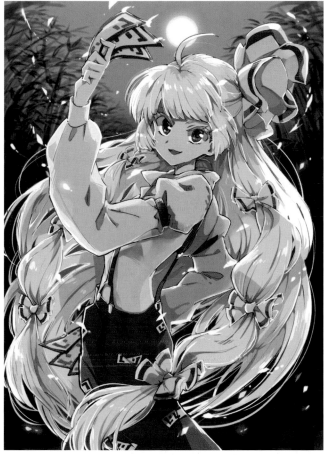

◀ Create contrast through adjoining dim and bright-colored areas.

▼ Increase the highlights on the cheeks, head and arms and add blue to strengthen the feeling of night.

▲ The effects of the spell cards are scattered throughout, making the dark areas darker while adding brightness overall.

▲ Blue is added not only to the character but also to the background.

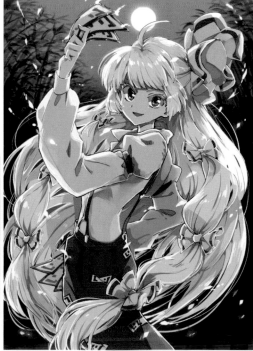

Canon Characters versus Original Characters

Basic difference

We all know what OC means; but it's often surprising to learn that some "original characters" are actually knockoffs, copies or versions of a character created by someone else. Where should the line be drawn? Where does an original character end and a transformative tribute begin? Does some fan art present problems in terms of copyright infringement? Most tasteful tributes are fair game, but it's important to consider and respect the differences between original intellectual property and fan art.

In the case of a canon character

A canon or canonical character already has an artistic and professional legacy; a creative provenance, if you will. It's a term used by fans of a particular franchise or series. In an act of creative appropriation, a new character is created or an existing one transformed. The canon character's world and storyline might derive from the original source or represent a radical relocation. Often the highest form of tribute comes in the form of a doppelgänger or a persona that's a radical departure from the original character. What makes a good character and a particular transformation effective is subjective of course. Tribute comes in many forms. As long as the interior logic of the illustration holds true, a canon character can assume many new forms.

In the case of an original character

An original character is just that, created by one artist, illustrator or designer. Often a team of colorists, letterers or art directors contributes to the cause; but in the case of an OC, one artist does all the heavy lifting from the first strokes of inspiration to the finalizing refinements.

Drawing each in your own individual style

It all comes down to individual style. No original character can ever be identically and exactly reproduced by another illustrator. So all tributes, riffs and transformations are naturally a reflection of an artist's individual style. Whether creating original characters or fan art, it's the distinctive details you add and your sense of dynamism and framing that will set your creations apart.

Illustrators Profiles

ユキ桜 [sophie]
■ Illustration
Cover illustration,
"Idol illustrations for posters"
(P72–83)
- http://www.pixiv.net/member.
 php?id=164904

朝日 (Asahi)
■ Illustration
"Touhou Project Niiwa Mamizo"
(P146–151)
- http://www.pixiv.net/member.
 php?id=1978658

荻野アつき (Ogino Atsuki)
■ Illustration
"Pop illustrations for magazines"
(P112–121)
- http://oginoatsuki.moo.jp/

しがらき (Shigaraki)
■ Illustration
"Adventurer boy illustration"
(P50–59)
- http://www.pixiv.net/member.
 php?id=1004274
- https://twitter.com/sshigaraki

シノアサ (Shinoasa)
■ Illustration
"Touhou Project Fujiwara Sister
Beni" (P152–157)
- http://www.pixiv.net/member.
 php?id=747452

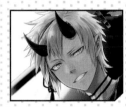

染宮すずめ (Somemiya Suzume)
■ Illustration
"Demon swordfighter
illustration"
(P38–49)
- http://www.pixiv.net/member.
 php?id=890482

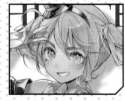

DSマイル (DS Miles)
■ Illustration
"Illustrations for magazine
covers"
(P122–133)
- http://www.pixiv.net/member.
 php?id=795196

トマリ (Tomari)
■ Illustration
"Female character illustration of
a seamstress"
(P60–68)
- http://ttomarii.tumblr.com/

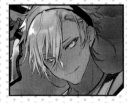

野崎つばた (Nozaki Tsubata)
■ Illustration
"Fantasy illustrations for graphic
novel covers"
(P84–97)
- https://tsubatako.jimdo.com/
- http://www.pixiv.net/member.
 php?id=1773916

hagi
■ Illustration
"Dynamic illustrations for manga
covers"
(P98–111)
- http://www.pixiv.net/member.
 php?id=2249236
- https://twitter.com/hagi_potato

ももしき (Moshiki)
■ Illustration
"Magical girl character
illustration"
(P22–37)
- http://www.pixiv.net/member.
 php?id=220294

よとい (Yotoi)
■ Illustration
"Stylish illustrations for CD
jackets"
(P134–144)
- http://www.pixiv.net/member.
 php?id=16072010

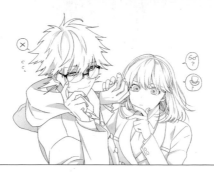

"Books to Span the East and West"

Tuttle Publishing was founded in 1832 in the small New England town of Rutland, Vermont [USA]. Our core values remain as strong today as they were then—to publish best-in-class books which bring people together one page at a time. In 1948, we established a publishing office in Japan—and Tuttle is now a leader in publishing English-language books about the arts, languages and cultures of Asia. The world has become a much smaller place today and Asia's economic and cultural influence has grown. Yet the need for meaningful dialogue and information about this diverse region has never been greater. Over the past seven decades, Tuttle has published thousands of books on subjects ranging from martial arts and paper crafts to language learning and literature—and our talented authors, illustrators, designers and photographers have won many prestigious awards. We welcome you to explore the wealth of information available on Asia at **www.tuttlepublishing.com**.

Published by Tuttle Publishing, an imprint of Periplus Editions (HK) Ltd.

www.tuttlepublishing.com

ISBN 978-4-8053-1727-3

English Translation © 2023 Periplus Editions (HK) Ltd

MONOGATARI WO UGOKASU CHARACTER DESIGN
 TO ILLUST NO EGAKIKATA
©2017 STUDIO HARD, Mynavi Publishing Corporation
English translation rights arranged with
 Mynavi Publishing Corporation through
 Japan UNI Agency, Inc., Tokyo

Library of Congress Cataloging-in-Publication Data in process

25 24 23 22 10 9 8 7 6 5 4 3 2 1
Printed in China 2211EP

Distributed by

North America, Latin America & Europe
Tuttle Publishing
364 Innovation Drive,
North Clarendon,
VT 05759-9436, USA
Tel: 1 (802) 773 8930; Fax: 1 (802) 773 6993
info@tuttlepublishing.com
www.tuttlepublishing.com

Japan
Tuttle Publishing
Yaekari Building 3rd Floor
5-4-12 Osaki
Shinagawa-ku
Tokyo 141-0032
Tel: (81) 3 5437-0171; Fax: (81) 3 5437-0755
sales@tuttle.co.jp
www.tuttle.co.jp

Asia Pacific
Berkeley Books Pte. Ltd.
3 Kallang Sector #04-01
Singapore 349278
Tel: (65) 67412178; Fax: (65) 67412179
inquiries@periplus.com.sg
www.tuttlepublishing.com